The Campus History Series

YOUNGSTOWN STATE UNIVERSITY
FROM YOCO TO YSU

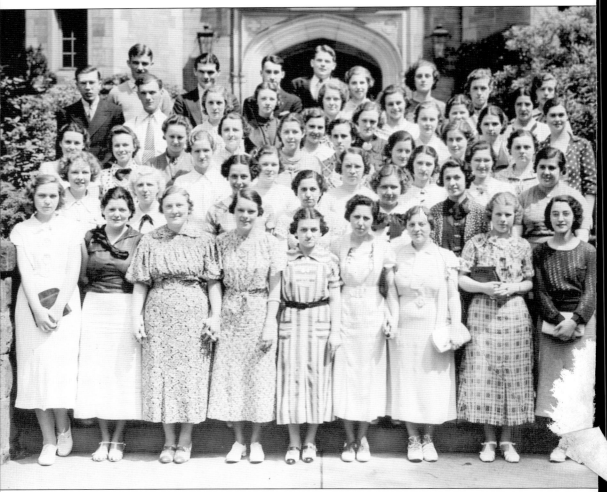

FRESHMAN CLASS OF 1932. Posing in front of the newly constructed Main Building is the 1932 freshman class of Youngstown College. The Main Building opened in 1931; it was renamed Jones Hall in 1966, to honor the college's first president, Dr. Howard Jones. Jones Hall became the signature icon for Youngstown State University from its completion.

On the cover: **PEACE CARAVAN.** In 1947, a group of students from the Peace Caravan met with Pres. Howard Jones. They are seen here in front of the Main Building. (Courtesy of Youngstown State University.)

The Campus History Series

YOUNGSTOWN STATE UNIVERSITY

FROM YOCO TO YSU

DONNA M. DEBLASIO AND MARTHA I. PALLANTE

ARCADIA
PUBLISHING

Published by Arcadia Publishing
Charleston SC, Chicago IL, Portsmouth NH, San Francisco CA

Printed in the United States of America

Library of Congress Catalog Card Number: 2006940643

For all general information contact Arcadia Publishing at:
Telephone 843-853-2070
Fax 843-853-0044
E-mail sales@arcadiapublishing.com
For customer service and orders:
Toll-Free 1-888-313-2665

Visit us on the Internet at www.arcadiapublishing.com

To the students of Youngstown State University—past, present, and future.

CONTENTS

ACKNOWLEDGMENTS

Youngstown State University: From YoCo to YSU could not have become a reality without the assistance of many people. We would like to thank the administration of YSU who provided financial assistance and release time for this project. Our two graduate assistants assigned to the YSU project received three years of funding from the president's office. Pres. David Sweet, Dr. George McCloud, and former provost Dr. Tony Atwater supported the project.

We were fortunate to have the assistance of Susan Tietz and Greg Weimer, our graduate assistants on the YSU history project, for the past three years. They worked diligently searching out photographs and archival information used in this book. Other history graduate students also worked on the project: Shannon Skiles, Jonathan Kinser, Ashley Zampona, and Rebecca Smith. These students worked hard, above and beyond the call of duty, especially during the proverbial "crunch time" as the publication deadline loomed. Thanks also to Bonita Harris, our invaluable history department administrative assistant, who provided us with much-needed computer skills and expertise.

We also owe a special thanks to the staff in the archives at Maag Library, especially library director Paul Kobulnicky, archives director S. Victor Fleisher, and members of their staff, including Brian K. Brennan, Mary Ann Johnson, Amy J. Kyte, Emily R. Lockhart, and Cortney R. Parsons. They not only assisted the researchers, but also made sure that the photographs were properly formatted for our use.

Other members of the YSU family provided assistance for the book, especially in seeking out images. We would like to thank photographers Jim Evans and Carl Leet and the staff of Athletics-Sports Information.

We would also like to thank the staffs of the Youngstown *Vindicator*, the Mahoning Valley Historical Society, the Public Library of Youngstown and Mahoning County, the William J. Clinton Presidential Library, and the Youngstown YMCA, especially YMCA staff member Al Leonhart. They provided valuable images missing from our own collections. John Kai Lassen allowed use of photographs from his family collection that were especially important in documenting the late-19th-century history of Wick Avenue.

Some of the information collected for this work was drawn from the Youngstown State University *Neon* (1957–1979), and the Youngstown University and Youngstown State University *Bulletins* (1955–2006).

Finally we thank our families. They endured our long working hours and endless discussion of arcane facts about Youngstown State University. They laughed at the tales of Pete and Penny, even when they believed we had lost our minds. Their support, as always, was invaluable. Thank you, Brian Corbin, Glen Schaefer, and Sara, Laura, and Paula.

Unless otherwise stated, all images are courtesy of Youngstown State University.

INTRODUCTION

Youngstown State University, in all of its manifestations, has always reflected and been embedded in the fabric of the Mahoning Valley. The YMCA school of the early 20th century catered to the needs of working people who wished to further their education, as well as responding to the burgeoning steel industry by offering engineering and other technical courses. At the beginning of the 21st century, the university remains responsive to the realities of an economy and community entering a new phase of its existence. No longer a center of steel production, the Mahoning Valley is transforming itself—and YSU as well—into an institution that caters to the social, technical, and industrial needs of a post-industrial society.

The institution dramatically remade the built environment of Youngstown as it grew from a YMCA law school into a comprehensive university. The YMCA began offering courses in its downtown facility, but by the third decade of the 20th century expanded north onto Wick Avenue. The dramatic growth of the school reflected the requirements of an industrializing society for more skilled and professional personnel. In the last half of the 20th century, the foundation of the institution's new schools embraced the demand for more specialized skills, technologies, and conceptual frameworks. This translated into new facilities to house those endeavors, as faculty and students engaged in academic exchange. The 21st century campus bears little physical resemblance to the fledgling YMCA school of 1908, but the soul—the mind or spirit set free—remains constant.

In 1908, the evening school operated by the YMCA, the institution that became Youngstown State University, then located in downtown Youngstown, offered its first post-secondary classes in business law. The year 1920 was a watershed year for the fledgling educational institution when the State of Ohio empowered the school to grant the bachelor of laws degree and the school also began to offer a four-year bachelor's degree in the business administration program. The following year, the administration changed the name to the Youngstown Institute of Technology and two years later moved to the old Bonnell mansion on Wick Avenue, next to the Reuben McMillan Free Library. The faculty offered the first liberal arts courses in 1921 and established the College of Liberal Arts in 1927, and offered its first daytime classes. It later became the College of Arts and Sciences, and in 2007 the College of Liberal Arts and Social Sciences. In 1928, the institute changed its name to Youngstown College and conferred its first bachelor of arts degree in 1930. The first building constructed specifically for Youngstown College, known as the Main Building, opened in 1931. The Main Building was rechristened Jones Hall in honor of Howard Jones, the college's first president, in 1966.

The college ended its association with the YMCA in 1944, and in 1955, the institution was rechartered as Youngstown University. In 1967, Youngstown University joined the Ohio state system and became Youngstown State University. The Dana Musical Institute,

originally located in Warren, Ohio, became a part of Youngstown College in 1941. The William Rayen School of Engineering was established in 1946, several years after the creation of the engineering department. In 2007, it became the College of Science, Technology, Engineering and Mathematics. Other colleges and schools include the School of Business Administration (now Warren Williamson College of Business Administration, 1948), School of Education (now Beeghley College of Education, 1960), School of Graduate Studies and Research (1968), College of Applied Science and Technology (now Bitonte College of Health and Human Services, 1968), and College of Fine and Performing Arts (1974). In 1972, YSU joined a consortium with Kent State University and the University of Akron to form the Northeastern Ohio Universities College of Medicine (NEOUCOM), centrally located in Rootstown.

With the growth of the school in the mid-20th century came a building spurt as it outgrew the many old houses and other structures it occupied on Wick Avenue and vicinity. Some of the new construction included Ward Beecher Hall (science building, 1958), Kilcawley Student Center (1965), Maag Library (1975), Cushwa Hall (Bitonte College of Health and Human Services, 1976), DeBartolo Hall (College of Arts and Sciences, 1977), Bliss Hall (1976), Meshel Hall (1986), and the Andrews Student Recreation and Wellness Center (2005). To attract more students from outside of the area, the university also built new residence halls in the 1990s and University Courtyard Apartments in 2002.

In a community devastated by the closing of its steel mills beginning in 1977 and the erosion of its inner city and downtown, YSU is a major force for stability as well as employment. The four NCAA-1AA national football championships YSU won in the 1990s were an important boost to the region's morale. More than that, however, YSU is playing a major role in plans for the city's redevelopment, including implementing a centennial master plan for the campus and its surrounding neighborhood.

One

WICK AVENUE BEFORE YOUNGSTOWN STATE UNIVERSITY

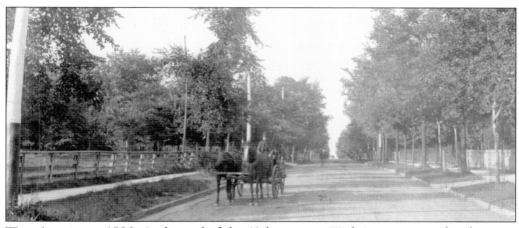

WICK AVENUE, *c.* 1890. At the end of the 19th century, Wick Avenue was a lovely street lined with stately elm trees and elegant houses. Youngstown, prior to the establishment of its college, was a thriving and growing community, mainly due to the development of its iron and steel industry. The city, founded in 1796 by Connecticut Land Company speculator John Young, had a population of approximately 45,000 in 1900. Named the county seat of Mahoning County in 1875, Youngstown became the center of government, commerce, industry, and culture. As the city grew beyond its downtown, its prominent families began building magnificent mansions on Wick Avenue and surrounding streets, just north of the business district. By the late 19th century, Wick Avenue could truly be called "Millionaire's Row." (Courtesy of John Kai Lassen.)

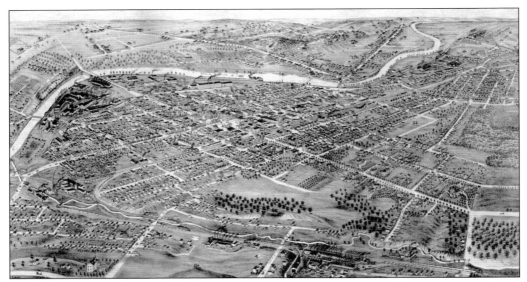

PANORAMA, 1882. The 1882 panoramic map of Youngstown demonstrates the growth of the city north from the downtown. The city's burgeoning iron industry was located along the banks of the Mahoning River, which is seen near the top of the map. The south side, because of the steep bank known as the "impassable ridge," did not experience the same rate of growth as the more accessible north side. The completion of the Market Street viaduct in 1899 connected the central business district with the south side, allowing for more development in that direction. (Courtesy of the Library of Congress.)

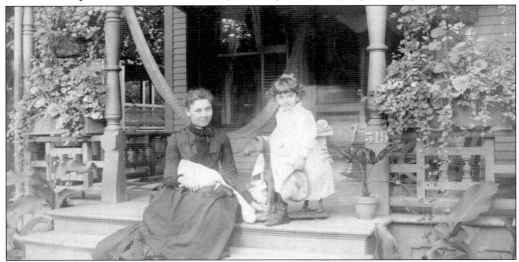

ELIZABETH BONNELL WICK AND SON PHILIP. The Bonnell and Wick families were two of the city's longtime leaders in business, industry, and commerce. Elizabeth Bonnell Wick's father was William Scott Bonnell, one of the founders of Brown, Bonnell and Company, which was eventually absorbed by Republic Iron and Steel. Her husband, and Philip's father, was Myron C. Wick, who was a shareholder in the Cartright and McCurdy Rolling Mill and an organizer of the Dollar Savings and Trust Company, as well as an early president of the Youngstown YMCA. Mother and son are seated on their front porch at 519 Wick Avenue in 1890. (Courtesy of John Kai Lassen.)

OLIVE ARMS. The daughter of Charles D. and Hannah Wick Arms, Olive Arms married her distant cousin Wilford Arms in 1899. The couple built their home on Wick Avenue next to Olive's childhood mansion. The Cleveland firm of Mead and Garfield designed the arts and crafts mansion, with considerable input from Olive, herself a talented artist. Completed in 1905, the rock-faced limestone residence exhibits the arts and crafts emphasis on the use of native materials and incorporating nature within the structure, at least metaphorically. After her death in 1960, Olive gave her home to the Mahoning Valley Historical Society for use as a museum. (Courtesy of the Mahoning Valley Historical Society, Youngstown, Ohio.)

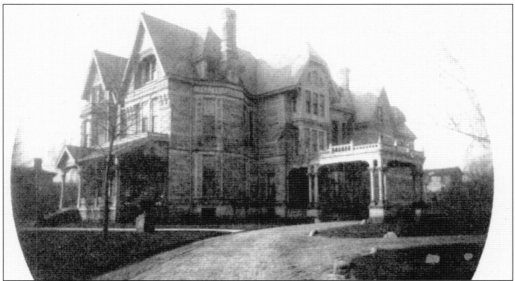

CHARLES DAYTON AND HANNAH WICK ARMS HOUSE. Charles Dayton Arms, a leading iron entrepreneur, built this house in 1881. The three-story residence is in the Romanesque Revival style, with its masonry structure and rounded, arched windows. The Holy Trinity Romanian Church purchased the building in the mid-1940s when Andrei Rosseau remodeled it for use as a church. Rosseau retained the original imported cherry and mahogany interior woodwork. (Courtesy of the Mahoning Valley Historical Society, Youngstown, Ohio.)

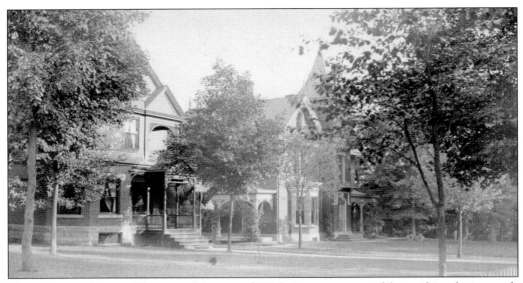

WICK AVENUE LAWNS. The grand lawns of Wick Avenue are visible in this photograph from 1890, giving "Millionaire's Row" a country feel, despite being in the heart of the city. (Courtesy of John Kai Lassen.)

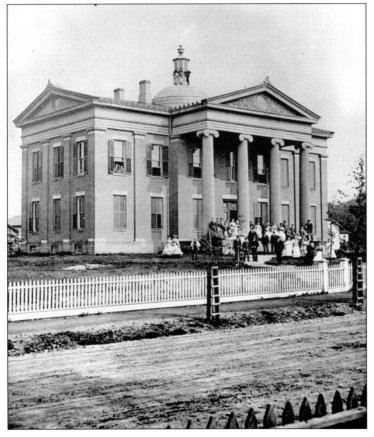

OLD RAYEN SCHOOL, c. 1876. Completed in 1866 at the corner of Wick and Rayen Avenues, Youngstown's first high school, the Rayen School, was named in honor of Judge William Rayen. The presence of an educational institution on Wick Avenue presaged its future as the city's center of higher education as well as other cultural icons. In the 1920s, the Youngstown Board Education, citing the need for a larger building, erected a new structure on the city's upper north side. Youngstown College, in 1944, purchased the old Rayen School for its School of Engineering. (Courtesy of the Vindicator.)

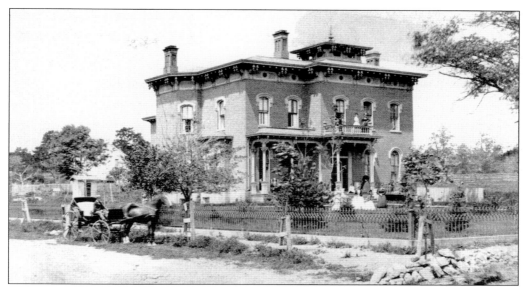

MYRON I. ARMS RESIDENCE. Myron Arms did not live to see the completion of his home at 606 Wick Avenue. This Italianate house, with its low-pitched hipped roof, deep eaves with brackets, and long narrow windows, was completed in 1866; Myron died two years earlier. (Courtesy of the Mahoning Valley Historical Society, Youngstown, Ohio.)

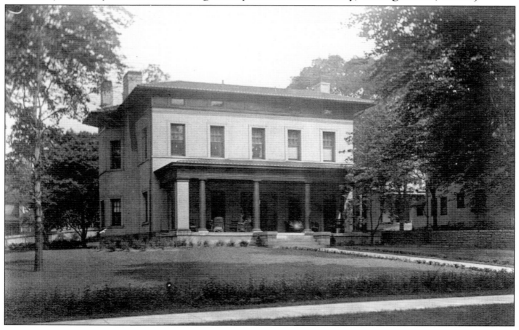

ALUMNI HOUSE. In the early 20th century, the owners of 606 Wick Avenue did a major rehabilitation of the Myron I. Arms house. Charles H. Booth, part owner of the Lloyd C. Booth Company, which was involved in the iron industry, lived here around 1901. In the late 20th century, the building became a part of Youngstown State University (YSU), currently housing the alumni association. (Courtesy of the Mahoning Valley Historical Society, Youngstown, Ohio.)

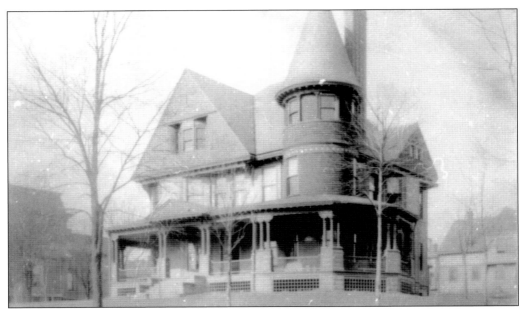

PORTER AND MARY WICK POLLOCK HOUSE. In 1893, noted Youngstown architect Charles H. Owsley designed this Queen Anne house for Margaret Wick, the widow of Paul Wick. In 1897, Paul's daughter, Mary married Porter Pollock, scion of the Pollock family who owned and operated the William B. Pollock Company, producers of blast furnaces, ladle cars, and other machinery. Owsley enlarged the original mansion to accommodate the newlyweds who moved in with Margaret Wick. The Pollock family donated the house to YSU; it was converted into the Wick-Pollock Inn in the 1980s. (Courtesy of the Mahoning Valley Historical Society, Youngstown, Ohio.)

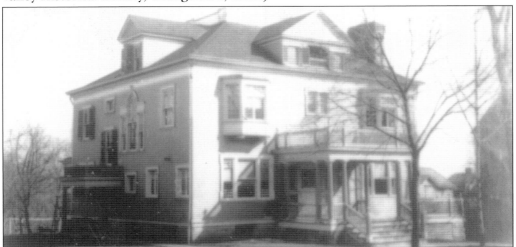

GEORGE AND EMELINE ARMS PECK HOUSE. Charles H. Owsley also designed this graceful Colonial Revival house for Dr. George and Emeline Peck in 1888. Emeline was the daughter of Myron I. Arms. George was a distinguished local physician who helped found City Hospital (later South Side Hospital) and also served as president of the Ohio Medical Association. YSU currently owns the structure located at 631 Wick Avenue. (Courtesy of the Mahoning Valley Historical Society, Youngstown, Ohio.)

Two

THE EARLY YEARS

YoCo Logo. Following the Civil War, the YMCA was one of the only organizations that recognized the need for urban institutions of higher learning. The Youngstown YMCA, incorporated in 1883, began offering night courses five years later. In 1908, the YMCA school introduced its first post-secondary classes. In 1920, the school was renamed the Youngstown Institute of Technology, and in 1928 became Youngstown College, introducing the YC logo.

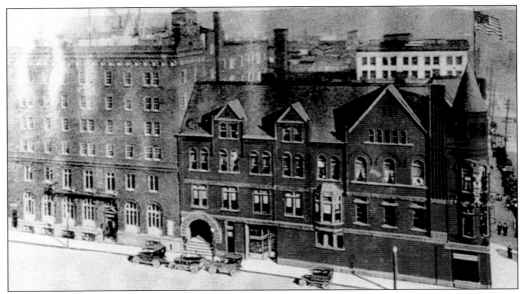

FIRST YMCA BUILDING. The Youngstown YMCA was incorporated in 1883. The YMCA first rented rooms in a downtown commercial building at 127 West Federal Street until the completion of this structure in 1892. Designed by local architect Louis Boucherle, the new YMCA was located at the corner of Champion and East Federal Streets. It is a Richardsonian Romanesque design, with its heavy rounded arches, short columns, and rock-faced masonry cladding. The first classes of the Youngstown Association School were held on the third floor of this building. (Courtesy of the Vindicator.)

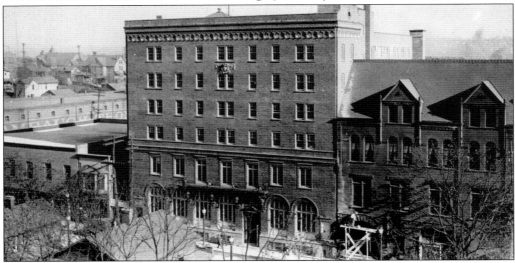

NEW YMCA BUILDING. The YMCA outgrew its old building and in 1915 constructed a new structure adjacent to the old. The YMCA offered more classes, including commercial law, in 1908, from which YSU traditionally dates its origins. In 1916, the YMCA incorporated the Youngstown Association School, which included significant new provisions, most importantly making the school coed. That same year, the school also began to offer English classes to assist the many immigrants who came to the Mahoning Valley in search of good jobs in the local steel mills.

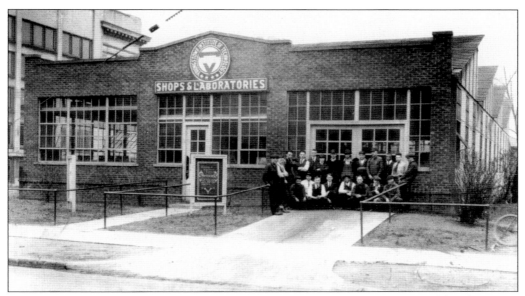

YMCA AUTOMOTIVE TECHNOLOGY BUILDING. Responding to the growing need for the repair and maintenance of automobiles in the second and third decades of the 20th century, the YMCA began offering classes to do just that. The building seen here, which was located behind the Main Building of the Public Library of Youngstown and Mahoning County, was built to house the new courses. The YMCA noted that its students took courses in laboratory work, studies in automobile operation, machine shop, battery and welding instruction, and a thorough course in automobile repair. (Courtesy of the Youngstown YMCA.)

YMCA AUTOMOTIVE CLASS. These men participated in an auto mechanics course, located in the Automotive Technology Building. The YMCA noted that instruction was "given by practical men." Reflecting the emphasis on training for the trades, in addition to its academic and professional courses, the YMCA changed the name of its school to the Youngstown Institute of Technology in 1921. (Courtesy of the Youngstown YMCA.)

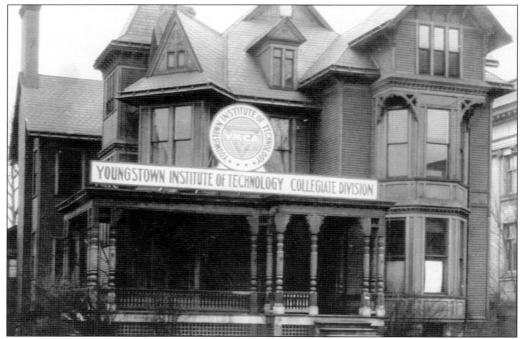

BONNELL HOUSE. In search of more classroom space, the YMCA rented out the old Bonnell house located at 315 Wick Avenue, between the Reuben McMillan Free Library and St. John's Episcopal Church. The YMCA paid $3,400 per year for rent for the first three years. There were classrooms and offices on the first floor, classrooms on the second floor, drafting rooms on the top floor, and laboratories in the basement. The laboratories and drafting rooms were for students in the engineering program. The law school moved into the Bonnell Building in 1924.

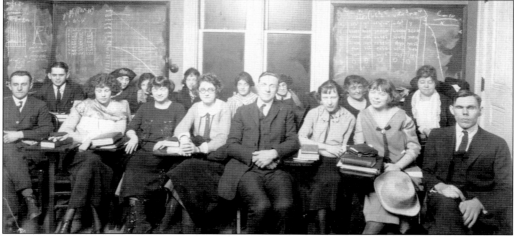

THE 1922 LIBERAL ARTS CLASS IN BONNELL BUILDING. Students in the liberal arts class were part of the YMCA's academic program. By 1920, the YMCA was also offering many other courses including arithmetic, algebra, geometry, trigonometry, English, mechanical drawing, architectural drawing, electricity, metallurgy, steam engine and boiler repair, radio telegraphy, sign writing, cartoon drawing, stenography, typewriting, bookkeeping, and penmanship.

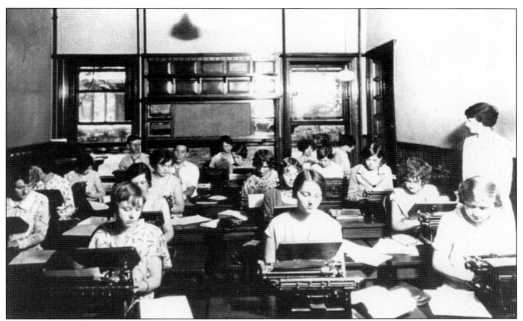

Mabel Harriet's Business School Typing Class, 1927–1928. In 1924, the YMCA offered a program leading to a bachelor's degree in commercial science. Modern businesses demanded professional secretaries; the YMCA's new program helped to fill this need as well as adding more women to the white-collar workforce.

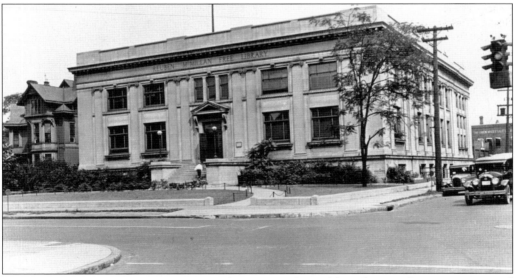

Reuben McMillan Free Library. Now known as the Public Library of Youngstown and Mahoning County, the library's trustees constructed a new Main Building in 1910. The library began in an old house in downtown Youngstown but moved north onto Wick Avenue as the city's population grew. The Youngstown architectural firm of Owsley, Owsley and Boucherle designed this neoclassical building, reflecting the interest in classicism that was predominant in the early 20th century. Youngstown College utilized the public library until it built its own facility in 1952.

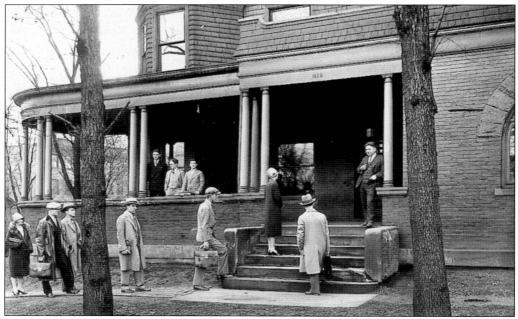

Students Outside John C. Wick Building. The Bonnell Building did not fully satisfy the space needs of the Youngstown Institute of Technology, so in 1923, it purchased the John C. Wick mansion on the corner of Lincoln and Wick Avenues for $125,000. This photograph of the exterior of the Wick Building was taken around 1929.

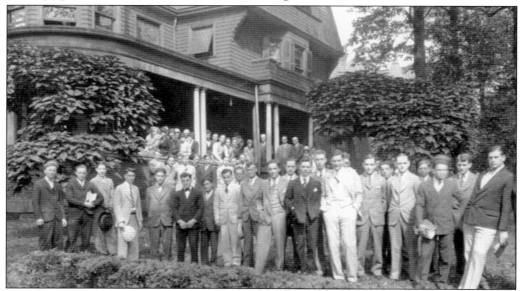

Liberal Arts Class Outside of Wick Building. The popularity of the liberal arts classes grew when the YMCA started offering courses during the day. With the expansion of the academic offerings, greater numbers of traditional students began attending the school. In 1930, the State of Ohio authorized the College of Liberal Arts to grant the bachelor of arts degree. That same year, the name of the school officially changed to Youngstown College.

INTERIOR OF THE JOHN C. WICK BUILDING. While the YMCA adapted the old John Wick mansion for use as classroom space, it did attempt to retain some of the elaborate architectural details. This photograph shows the grandeur of the long-gone mansion, from a time when Wick Avenue was "Millionaire's Row."

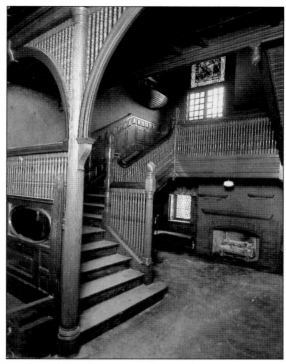

THE LAW LIBRARY INSIDE THE WICK BUILDING. The law school moved from the YMCA building downtown to the Bonnell Mansion in 1924 and three years later, into the Wick Building. In 1920, the Ohio State Department of Education authorized the YMCA to confer the bachelor of laws degree. The law library opened in 1927 and was installed in the Wick Building, as shown here.

CHEMISTRY STUDENT. By 1927, men and women constituted nearly equal numbers in the student body. This young woman is seen in a chemistry class around 1928.

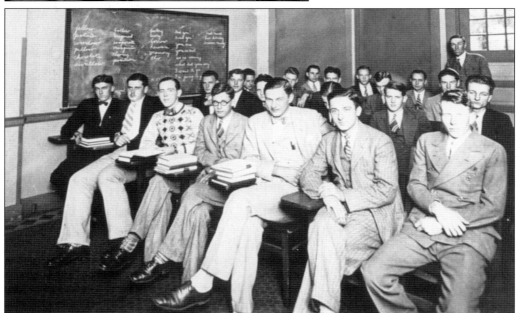

MATH CLASS. This math class is meeting in the John C. Wick Building around 1925. The crowded conditions speak eloquently to the need for a real classroom building, which was finally met in 1931. Note that there are no women students in the math class.

Three

FROM COLLEGE TO UNIVERSITY

YOUNGSTOWN COLLEGE LOGO. Administrators commissioned a new seal in 1931 featuring the Main Building in the center and the words "Young Men's Christian Association" beneath. Since its completion, the Main Building (Jones Hall) has become the signature building and icon of the university. By 1955, Youngstown College was a growing institution with several new buildings and a steadily increasing student population.

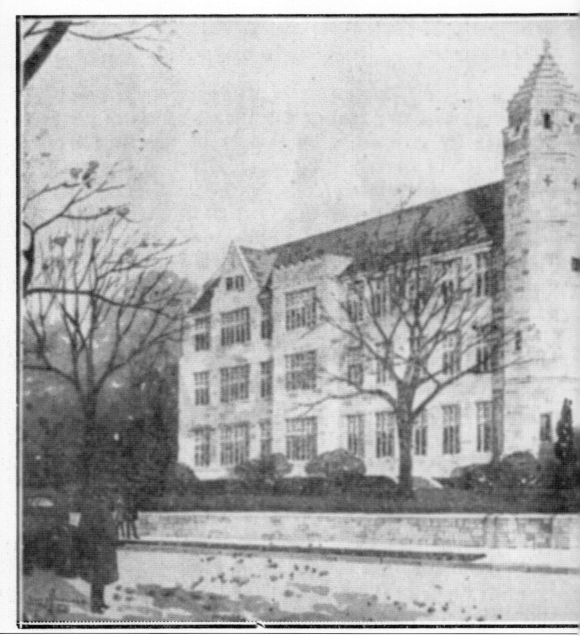

CORNERSTONE DEDICATION PROGRAM COVER. On Sunday, May 24, 1931, the YMCA laid the cornerstone for its new education building. The program, which was broadcast over radio station WKBN, included music by the Boys Band of the Central YMCA and the Glee Club of the Youngstown College of the YMCA; an invocation by Dr. W. E. Hammaker of Trinity

C. A. Educational Building Youngstown Ohio

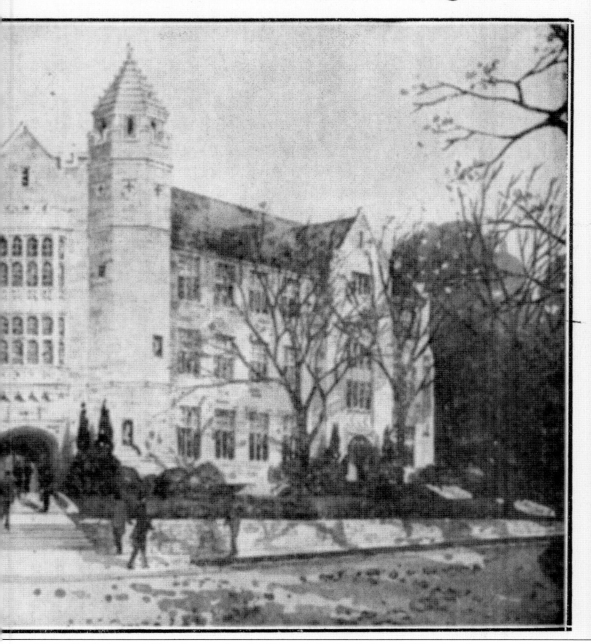

Methodist Episcopal Church; speeches by Henry A. Butler, Sydney Collins (an alumnus of the college), Dr. Leonard W. S. Stryker of St. John's Episcopal Church, and Guy Ohl (president of the YMCA board of trustees); and a benediction by Rev. Levi G. Batman of First Christian Church. James L. Wick presided over the ceremony. (Courtesy of the Youngstown YMCA.)

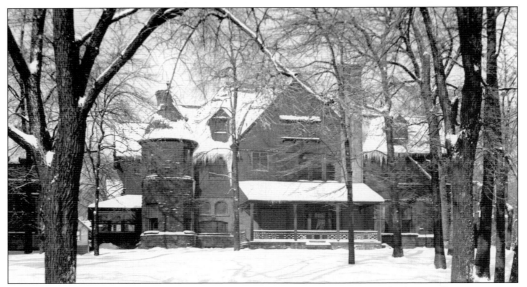

HENRY WICK BUILDING. The YMCA leased the mansion that once belonged to Henry C. Wick in 1928. It was used for additional classroom space. The house was located at 416 Wick Avenue, just north of the John C. Wick mansion. Finally purchased in 1938, the college renamed it East Hall and used it primarily for the secretarial school. The carriage house behind the old mansion was renamed West Hall and was also used for classrooms and later to house African American athletes.

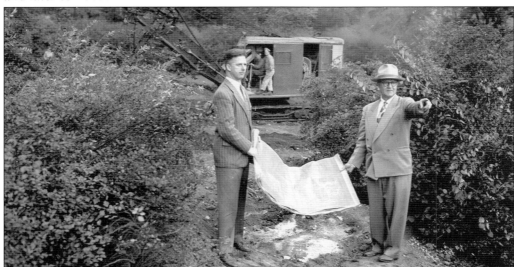

CLEARING LAND FOR CONSTRUCTION OF MAIN BUILDING. During the 1920s, the YMCA desperately needed more classroom space for its growing college program. In one of the shortest and most profitable capital campaigns in the university's history, spearheaded by the chairman of the building committee James L. Wick, the YMCA raised $1,175,000 during the evening of October 22, 1929. The site selected was the corner of Wick and Lincoln Avenues, where the YMCA already owned the John C. Wick house. In 1930, the Wick house was leveled and the land cleared, as shown in this photograph. Seen here are Howard Jones and the team working on the project.

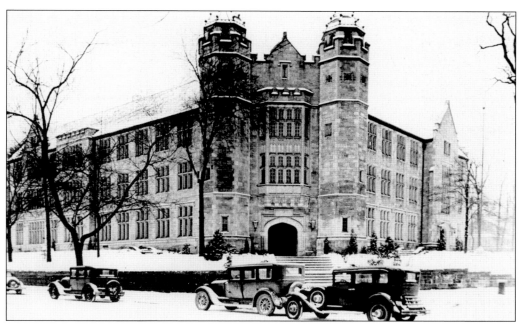

MAIN BUILDING, YOUNGSTOWN COLLEGE. The new Main Building was dedicated on October 1, 1931. Local architect Paul Boucherle designed the Jacobethan or Collegiate Gothic structure. Located on the corner of Wick and Lincoln Avenues, the three-story building is constructed of Indiana limestone and originally had 34 classrooms, a library, a cafeteria, laboratories, an auditorium, and executive offices. In 1949, the building was enlarged with the addition of the C. J. Strouss Memorial Auditorium.

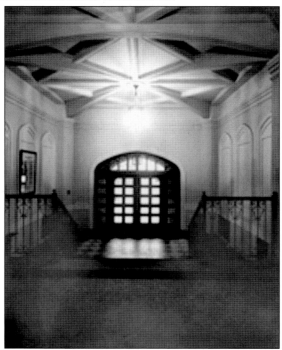

INTERIOR, YOUNGSTOWN COLLEGE MAIN BUILDING. This view of the main entrance lobby of the Main Building exhibits some of the architectural elements of the Jacobethan style. The ribbed vaulting in the ceiling and lancet arched doors give character to this grand structure. The doors give way to the corner of Wick and Lincoln Avenues.

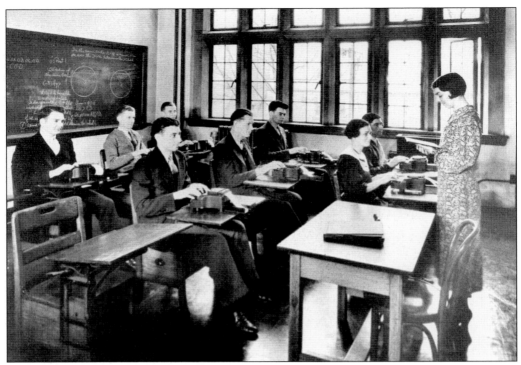

VERA JENKINS'S STENOTYPE CLASS, 1935. Even as late as the 1930s, the secretarial profession was not yet dominated by women. This class, held inside the new Main Building, provided students with the latest in modern technology.

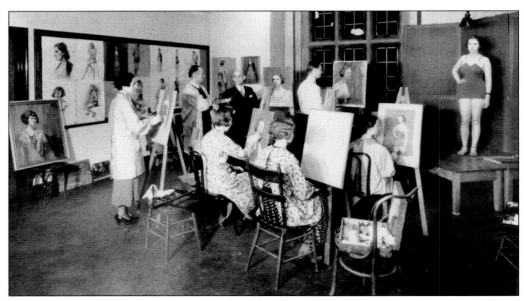

FINE ARTS CLASS, 1935. The fine arts class used live models to hone their artistic talents. This class, held on one of the upper floors of the Main Building, provided an opportunity for life drawing.

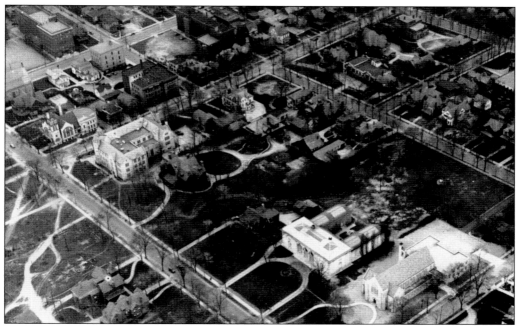

AERIAL VIEWS, YOUNGSTOWN COLLEGE CAMPUS, 1935 AND 1949. In 1935 (above), the Youngstown College campus sat between Wick Avenue on the east, Bryson Street on the west, Lincoln Avenue to the south, and the Butler Institute of American Art to the north. College buildings included the newly constructed Main Building, Henry Wick House to the north of the Main Building, and situated to the west were the cafeteria, the gymnasium, and the college's barns. By 1949 (below), with the exploding postwar student population thanks to the G.I. Bill, the college was in dire need of more classroom space. Army barracks, seen near the top center of the photograph, met some of the space requirements.

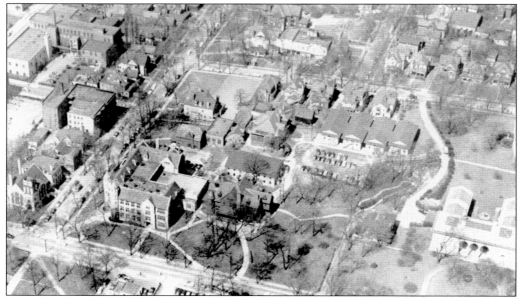

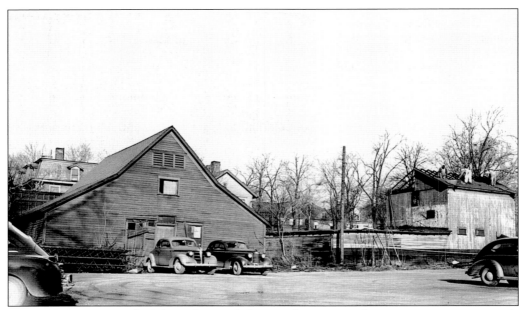

COLLEGE'S BARNS, 1947. These barns, leftovers from an earlier time in Youngstown's history, were soon to meet the wrecking crew after having outlived their relevance. (Courtesy of the Vindicator.)

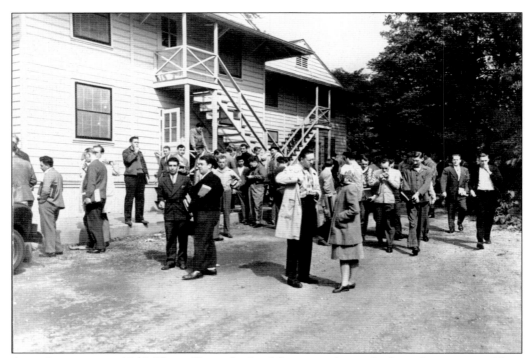

ARMY BARRACKS, *c.* 1949. The college obtained four army barracks from Camp Perry, Ohio, through the Federal Works Agency's surplus war goods, which temporarily eased campus crowding. Upon completion of Tod Hall in 1953, the college dismantled the barracks.

BERYL DENT IN FLYING CLASS.
Youngstown College offered
courses in flying. In 1939,
Beryl Dent was the only female
student in the class.

VETERANS COLLEGIATE ASSOCIATION, 1945. After proudly serving their country during
World War II, these veterans attended Youngstown College on the G.I. Bill. Thanks to
this remarkable piece of legislation, enrollment increased from just over 300 students
in the 1930s to more than 2,000 by the late 1940s.

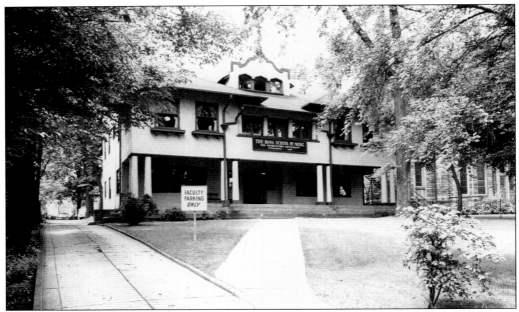

DANA SCHOOL OF MUSIC. Founded in Warren, Ohio, in 1869 by William Henry Dana as the Dana Musical Institute, the school merged with Youngstown College's Department of Music in 1941. The college purchased the Charles S. Thomas residence on Wick Avenue to house the new Dana School of Music.

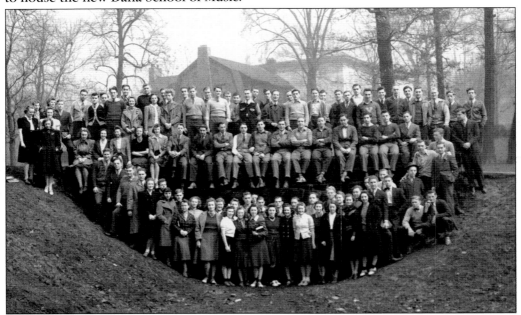

STUDENTS ON THE STONE BRIDGE. In the 1940s, this group of students posed on the stone bridge, adjacent to Wick Avenue, between the Butler Institute of American Art and the Main Building (Jones Hall). Immediately behind the group is the structure housing the president's residence and executive offices, which was once the home of Henry Butler. In the distant background is the Butler Institute of American Art.

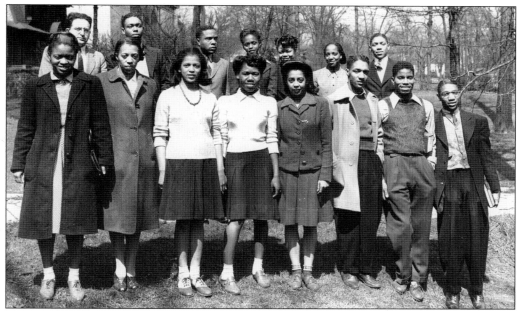

EXCELSIOR CLUB, 1942. Youngstown College's African American students had their own organization known as the Excelsior Club. Organized in October 1942, the club sponsored various activities including a formal dinner dance, a spring breakfast, and lectures. The first officers were Anne Black (president); Louis Tabor (vice president); Edna Wheeler (secretary); Corrine Lott (assistant secretary); and Reginald Sanders (treasurer). Other members were James Driscoll, Bernice Fleming, John Harris, Grace Irby, Elizabeth Lynch, Bishop McDuffie, James McDuffie, Marie Porter, Ray Prisby, Arthur Richard, Romeo Robinson, Eurad Rouse, William Scrugs, Ellsworth Smith, Harriet Snell, Albert Thomas, Warren Turner, Juanita Walton, Edna Wheeler, and Mary Jayne Young. Dr. Max A. Wolfe was the faculty advisor; he is in the second row on the far left.

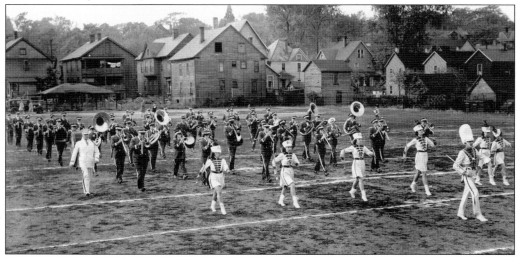

MARCHING BAND, 1948. In the aftermath of the war, with an increase in the male student population, the marching band became an integral part of Youngstown College's football games. Many leisure activities that were curtailed during the war reappeared on campus.

IT'S RED AND WHITE

By official action of Student Council the school colors have been changed from red and gold to red and white. The red is to be a cardinal shade. It's hard to accept a change in college traditions, but this change was required because of the difficulty that is always incurred when gold has to be put into print. We hope that servicemen who have written to discourage any change of this type will understand that this action was really necessary.

NEW YOUNGSTOWN COLLEGE COLORS. On May 7, 1945, the college's newspaper, the *Jambar*, reported that the student council voted to change Youngstown College's colors from red and gold to red and white. It is interesting to note their concern with the opinions of the men in the armed forces.

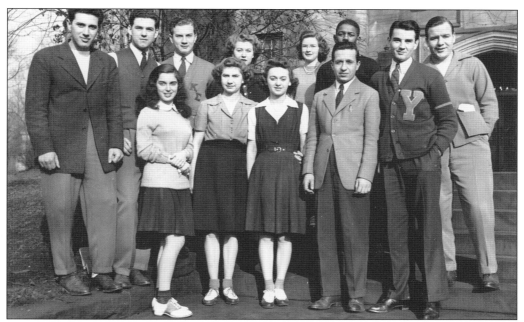

JAMBAR STAFF, 1944. Youngstown College students published two newspapers in the early 1930s. The *Hoot Owl* promoted student activities for those enrolled in night classes. In 1935, it merged with the *Jambar*. The title *Jambar* originated as a slang term indigenous to the Youngstown steel industry. It was a tool used to clean away accumulations at the mouth of a blast furnace.

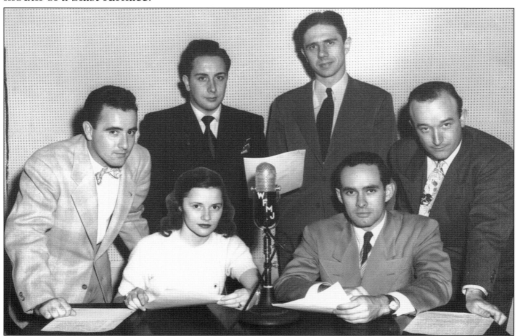

YOUNGSTOWN COLLEGE BROADCAST. On November 16, 1948, Youngstown College students broadcast from the studios of WFMJ in downtown Youngstown.

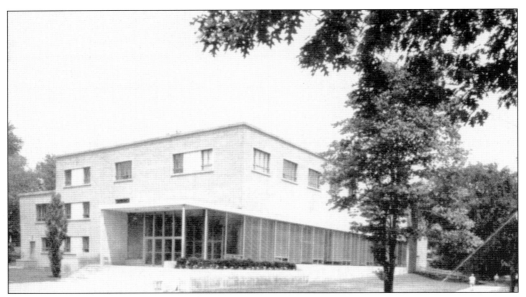

COLLEGE LIBRARY. In the early 1950s, Youngstown College razed the army barracks and erected a new building, which included classrooms and a library. The classroom space was known as John H. Tod Hall and was attached to the library; it opened in 1953, one year after the library.

STUDENTS TAKING SCHOLARSHIP EXAM. The new Youngstown College library provided quiet space for students taking a scholarship exam in the 1950s.

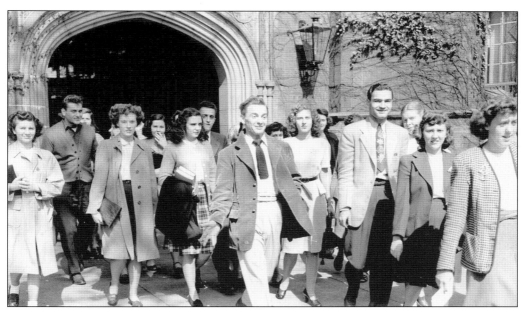

STUDENTS EXITING THE MAIN BUILDING. This group of students is leaving the Main Building at the end of the class day around 1945.

BUECHNER HALL, 1943. Buechner Hall, a privately owned residence for women, opened in 1931. Recognizing the needs of female students as well as career women, the residence provided safe and secure housing for this growing population. Buechner Hall is located on Bryson Street at the northern end of the campus. Today it provides housing for YSU female students and remains privately owned.

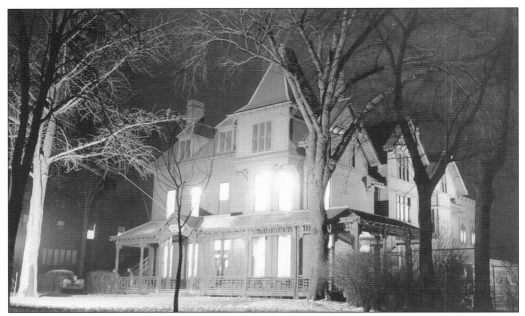

FORD HALL. Acquired for additional classroom space in 1951, Ford Hall was once one of the grand mansions of Wick Avenue. It was located on the southeast corner of Wick Avenue and Spring Street, at the site where Bliss Hall now stands.

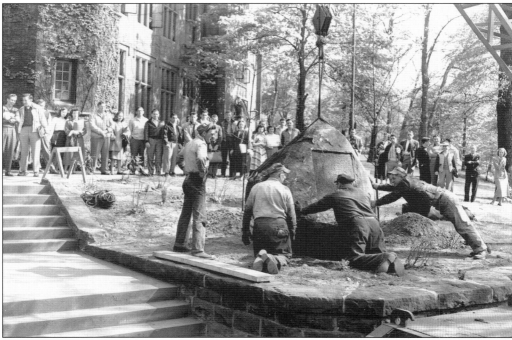

PLACING THE ROCK ON CAMPUS. In 1954, with students looking on, workers move the rock into place in front of the Main Building. A plaque on the rock indicates the year of the college's founding and over time has been updated reflecting the school's evolution from college to university to state institution.

Four

GOING STATE

YOUNGSTOWN UNIVERSITY SEAL. In 1955, when Youngstown College became Youngstown University, the school commissioned a new seal to reflect its changing status. Red on white, the symbol proclaims the university a beacon of knowledge, with the words "animus liberatus," the mind or spirit freed.

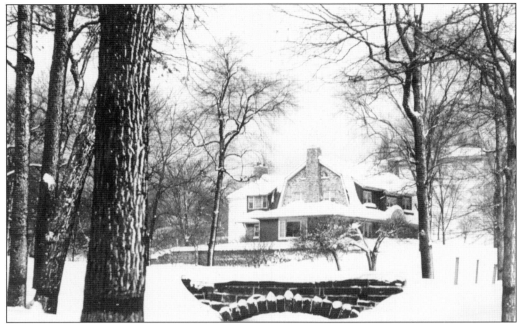

PRESIDENT'S HOUSE AND EXECUTIVE OFFICES. Youngstown College purchased the Henry Butler House on Wick Avenue, adjacent to the Butler Institute of American Art, in 1946 as a residence for the school's president as well as executive offices. The building, seen here in 1956, was demolished in the 1970s to make room for the new Maag Library.

STUDENTS ON STONE BRIDGE. Youngstown University students are relaxing on the stone bridge on Wick Avenue in 1958. The landscaping gives a parklike setting to the campus. The building in the right background is the president's house.

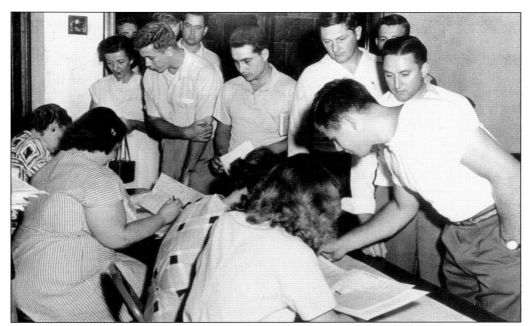

STUDENTS PAYING TUITION. Some things are eternal. Long student lines to pay tuition in 1956, seen here, can still be found in the contemporary bursar's office.

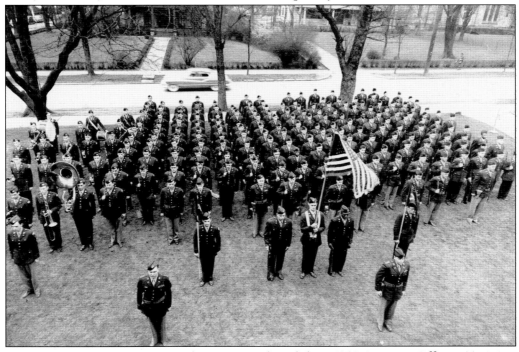

ROTC FORMATION. Pres. Howard Jones introduced the ROTC (Reserve Officers Training Corps) to the Youngstown College campus in September 1950. With the presence of the ROTC also came a new program in military science. This ROTC group, shown in formation, is from the 1950s.

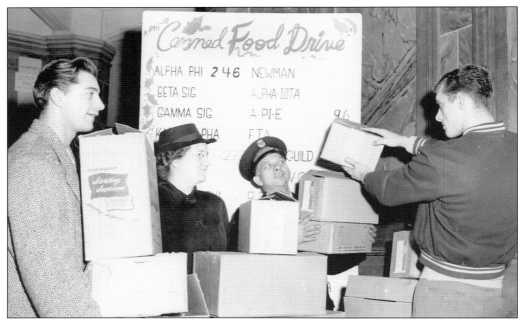

STUDENT FOOD DRIVE FOR THE SALVATION ARMY. Youngstown University is an integral part of the city's community life. Students from various on-campus organizations such as the Newman Club and fraternities and sororities collected food for the needy at Christmastime in the 1950s.

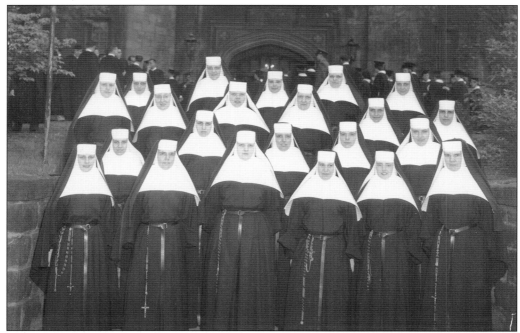

CATHOLIC NUNS GRADUATING FROM YOUNGSTOWN UNIVERSITY. The graduating class of 1959 included 22 Roman Catholic sisters from the Ursuline order. These women received bachelor of science in education degrees.

WARD BEECHER SCIENCE HALL. In 1958, Youngstown University opened its new science building, named after its benefactor, Ward Beecher. It boasted the latest in modern technology and research laboratories. (Courtesy of the Vindicator.)

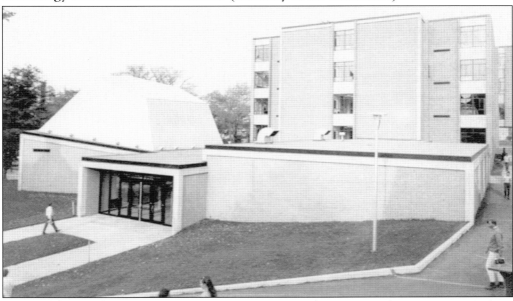

WARD BEECHER PLANETARIUM. The university needed to expand its science building and in 1966 began construction on an addition, which included a planetarium. In 2005–2006, the planetarium underwent a $750,000 renovation due to the generosity of the Ward Beecher and the Florence Simon Beecher foundations. The planetarium, in addition to serving the university, hosts hundreds of schoolchildren annually and also provides free programs to the general public.

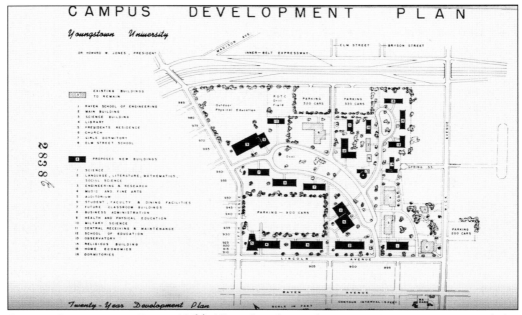

CAMPUS DEVELOPMENT PLAN, 1964. This plan drawn by Horace McLean envisioned the development of the Youngstown University campus for the next 20 years. It included the closing of Spring Street and the acquisition of an additional 65 acres on the west side of Wick Avenue, much of which came to fruition.

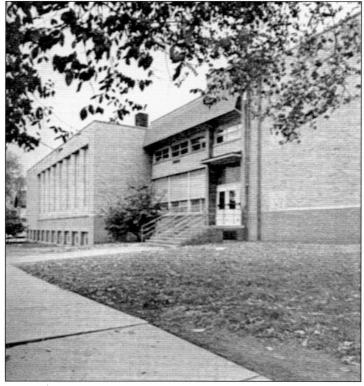

FEDOR HALL. The establishment of the School of Education in 1960 created the need for space to accommodate a growing enrollment. Youngstown University purchased the Elm Street School, a public grade school, in 1965. Renamed Fedor Hall, the School (later College) of Education moved into a new building in 1998.

KILCAWLEY CENTER RESIDENCE HALL. On September 11, 1965, the first students moved into the new Kilcawley Residence Hall. Designed as a two-phase project, with a new student center to be constructed directly to the west, the administration named it for its benefactors William H. and Mattie M. Kilcawley. The dormitory was the first on-campus residence in Youngstown University's history. It initially housed 210 men.

KILCAWLEY RESIDENTS. In 1966, Kilcawley residents took their meals under rather primitive conditions in the former snack bar.

STUDENTS ANALYZING LO-CARBON STEEL. These engineering students are learning how to analyze the structure of steel. The laboratory is in the old Rayen School of Engineering building on Wick Avenue.

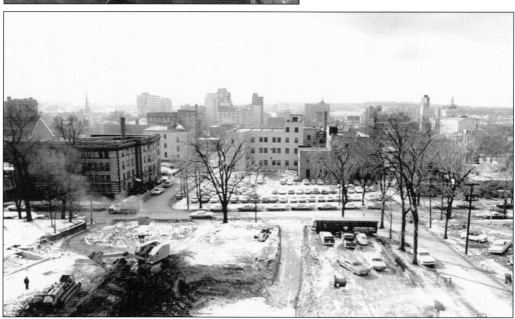

ENGINEERING SCHOOL CONSTRUCTION. As part of the mid-1960s expansion, Youngstown University undertook the construction of the new school of engineering building. Located at the intersection of Lincoln Avenue and Bryson Street, it opened the year the school went state, 1967. The engineering program grew by leaps and bounds thanks to the presence of the Mahoning Valley's steel industry. (Courtesy of the Vindicator.)

YOUNGSTOWN UNIVERSITY MARCHING BANDS. Marching bands remained a fixture at the institution during its university years. The band celebrated football victories, homecoming, and other community functions. The bands pictured here (above, 1956; and below, 1967) frame the school's years as a private university and illustrate the continuity of its traditions.

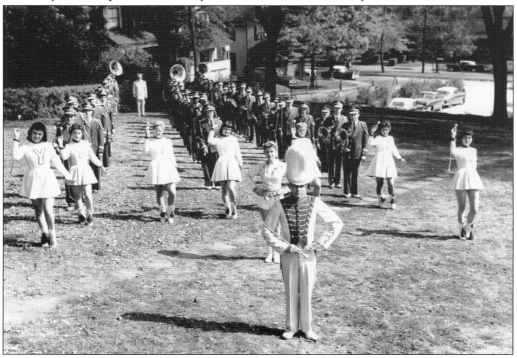

JONES HALL, *c.* **1960.** From the YMCA, to the Youngstown Institute of Technology, to Youngstown College, and Youngstown University, the Main Building remained an icon on the campus. It was renamed in 1966 in honor of its first president, Howard Jones, who retired in that year.

Five

PERSONALITIES

HOWARD JONES AND STUDENTS IN FRONT OF THE MAIN BUILDING. Throughout its 100-year history, many men and women made their impact on YSU. The college's first president, Dr. Howard Jones, put an indelible mark on the school. Dr. Jones oversaw the development of many long-standing traditions including the beginning of the building boom, the expansion of academic programs and colleges, the presence of ROTC, and the development of athletic programs. Dr. Jones is seen here with two students in 1949.

HOWARD JONES, 1935. Born in Palmyra, Ohio, on September 27, 1895, Howard Jones was educated at Hiram College and Western Reserve University. After a career at the Cleveland YMCA prep school and a stint as assistant to the president of Hiram College, Jones came to the newly minted Youngstown College. The *Jambar,* in 1931, described him as the "Executive type, steady on the trigger but twinkle in his eye and ready wit."

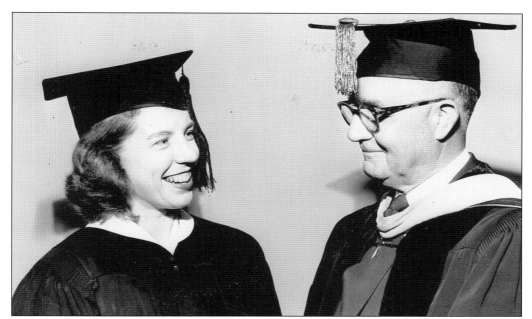

HOWARD JONES WITH DAUGHTER MARILYN. In 1954, Dr. Jones's daughter, Marilyn, graduated from Youngstown College. She is seen here with her father. By the mid-1950s, Dr. Jones oversaw the transformation of Youngstown College into Youngstown University the following year.

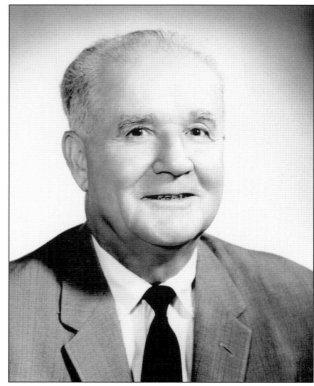

HOWARD JONES AT RETIREMENT. After serving the institution for 35 years, Howard Jones retired in 1966. Jones's last gift to the school he had faithfully served was to oversee the transition from private university to state institution.

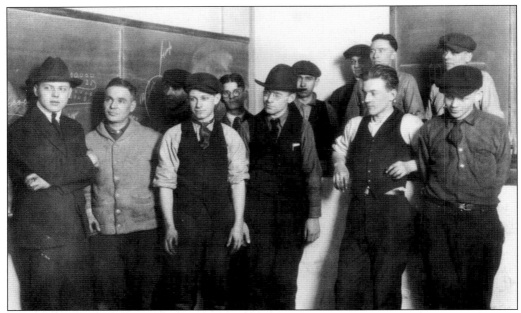

YMCA Students. YSU and its earlier incarnations could not exist without students. These men were typical of those enrolled in the YMCA automotive technology program. Note their instructor, on the far left, who is formally dressed in his suit and fedora. (Courtesy of the Youngstown YMCA.)

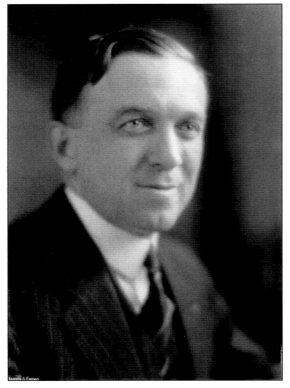

Leonard T. Skeggs. Leonard T. Skeggs was the educational secretary of the Youngstown YMCA and made plans for the development of Youngstown College. The Texas native oversaw the acquisition of the John C. Wick and Henry Wick houses for the use of the school. Because of his devotion to the YMCA, Skeggs opposed the separation of Youngstown College from its parent. In his honor, the university named its annual lecture series after Skeggs; speakers have included such notables as former New York governor Mario Cuomo, historian Dolores Kearns Goodwin, and activist Gloria Steinem. (Courtesy of the Youngstown YMCA.)

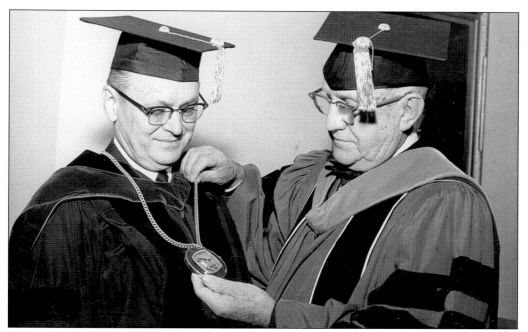

ALBERT PUGSLEY. The Howard Jones era came to an end in 1966 with the inauguration of Albert Pugsley as the university's second president. Prior to coming to Youngstown, Dr. Pugsley was administrative vice president at Kansas State University, where he acted previously as dean of academic administration and a faculty member in structural engineering. Under Dr. Pugsley, the school became a part of the state system of higher education. He served until his retirement in the spring of 1973; Pugsley passed away in 1977.

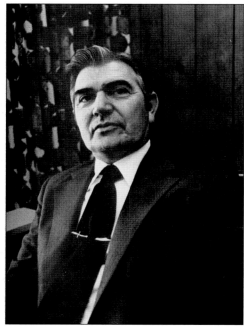

JOHN J. COFFELT. Named president of YSU in 1973, John Coffelt is generally credited with "developing the jewel of a campus we all enjoy so much." Coffelt was instrumental in the planning and development of Stambaugh Stadium, which opened in 1982. Unimpressed by position or titles, Coffelt often introduced himself, "I'm John Coffelt. I work at the university." He served the university until 1984 and died in 1989.

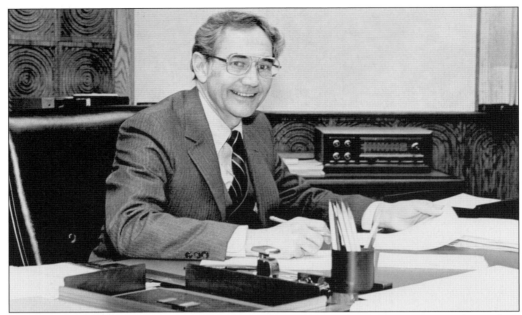

NEIL D. HUMPHREY. The university selected Dr. Neil Humphrey as acting president when John Coffelt went on medical leave in the fall of 1983. When Dr. Coffelt announced his retirement in 1984, the board of trustees named Dr. Humphrey president, forgoing a national search. Dr. Humphrey came to YSU from the University of Alaska, where he was vice president for financial affairs. He served as president until his retirement in 1991.

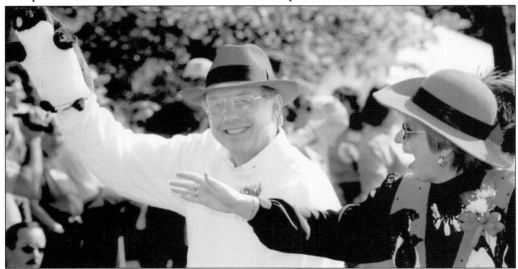

LESLIE H. COCHRAN. Dr. Leslie Cochran assumed the presidency of the university in 1992, becoming its fifth president. Prior to coming to YSU, he was the provost at Southeast Missouri State University. Dr. Cochran's goal was to move the university into the 21st century. During his tenure, the school quadrupled its grant applications and research capacity, as well as instituting the University Scholars program named for him. He and his wife, Lynn, in their trademark red hats, created a visible presence on campus and in the community, especially at YSU games.

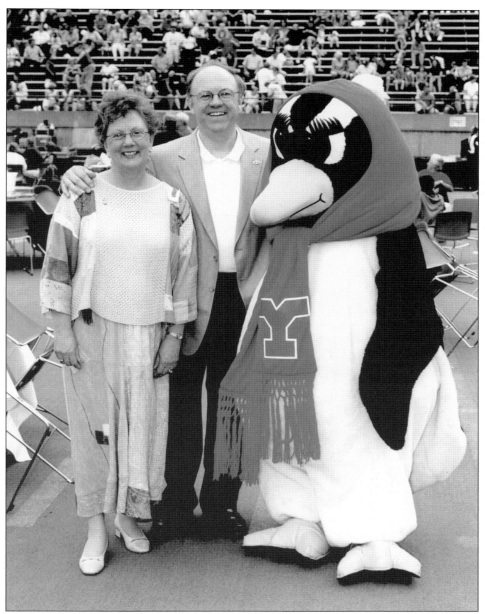

DAVID C. SWEET. When Leslie Cochran retired in 2000, a national search resulted in the selection of Dr. David C. Sweet of Cleveland to be YSU's sixth president. Prior to coming to YSU, Dr. Sweet was dean of Cleveland State University's Levin College of Urban Affairs, which he helped establish. Dr. Sweet, seen here with his wife, Patricia, and Penny Penguin, was instrumental in developing closer ties with the city of Youngstown, particularly in the area of urban planning. Part of Dr. Sweet's vision includes the implementation of the Youngstown 2010 plan, a blueprint for the revitalization of the city. His plan for the campus itself resulted in the construction of the new Andrews Student Recreation and Wellness Center in 2005 as well as a major capital campaign for the centennial, kicked off in the fall of 2006.

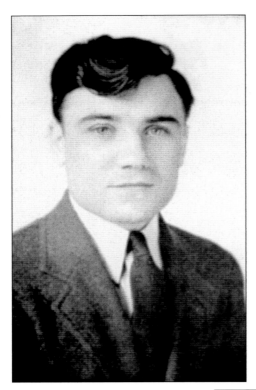

DOMINIC ROSSELLI. A Youngstown native, Dominic Rosselli came to Youngstown College in 1939 as an assistant football and basketball coach and became head basketball coach a year later. In 1948, Rosselli convinced the college to begin a baseball program, which he also lead. During his tenure at YSU, Rosselli compiled one of the greatest winning basketball records in the nation, according to the NCAA.

DWIGHT "DIKE" BEEDE. Dwight "Dike" Beede, a native of Youngstown, finished his career tied for fifth place among active college football coaches with 175 victories. He began his career at Youngstown College in 1938 as head coach of the newly minted football team, a position he held until his retirement in 1972. Beede received national recognition with his invention of the football penalty flag in 1941.

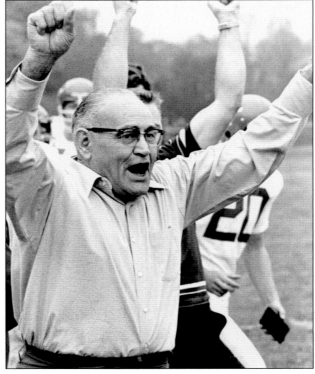

EDWARD DiGREGORIO. Longtime women's basketball coach Ed DiGregorio came to YSU in 1983 and established a winning tradition for the Lady Penguins. In his 20 seasons, DiGregorio compiled an impressive 319-241 record. His teams won five straight Mid-Continent Conference (MCC) championships and three MCC tournament titles. In 1998, he led YSU to its first NCAA tournament victory.

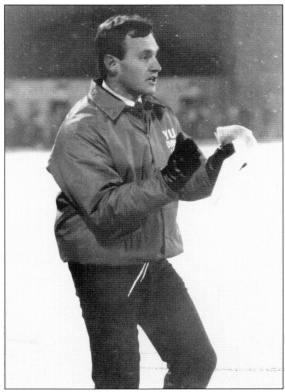

JIM TRESSEL. Ohio native Jim Tressel became the head football coach at YSU in 1985. During his 16-year tenure, Tressel captured the community's and the nation's attention compiling four NCAA-1AA national championships in 1991, 1993, 1994, and 1997.

MARY B. SMITH. Mary B. Smith came to Youngstown College in 1939 as an instructor in biology. Seven years later, she became head of the Health and Physical Education Department as well as assistant registrar. Working her way up through the ranks, in 1973, she became director of Career Planning and Placement. For over a third of a century she contributed to the steady growth and prestige of YSU.

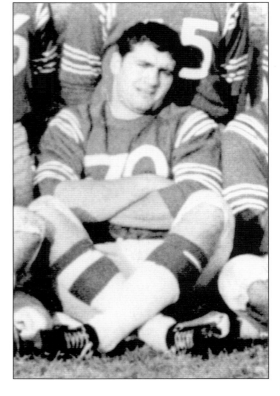

ED O'NEILL. The man who brought life to the uncouth Al Bundy on television's *Married with Children*, Ed O'Neill attended YSU in the late 1960s. O'Neill, who played football for the Penguins (seen here), was drafted by the Pittsburgh Steelers but failed to make the team. While at YSU, he starred in several theater productions including *Rosencrantz and Gildenstern are Dead*, *Six Characters in Search of an Author*, and *The Rose Tattoo*. O'Neill was Penguin of the Year in 1996.

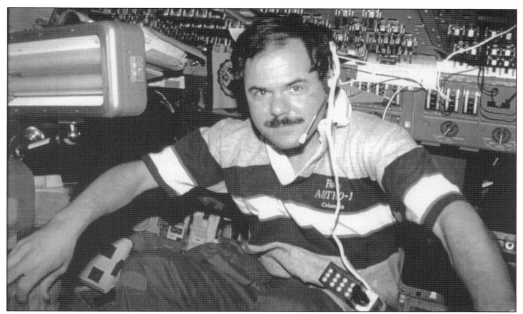

RON PARISE. A 1973 graduate of Youngstown State, Warren native Dr. Ron Parise earned a bachelor of science degree in physics and master of science and doctorate degrees in astronomy from the University of Florida. In March 1986, Dr. Parise began training as a payload specialist for NASA in anticipation of a mission on the space shuttle. He flew on the *Columbia* in December 1990 and on the *Endeavour* in March 1995, as part of "Astro" missions.

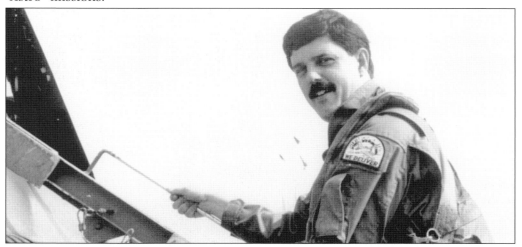

TERENCE M. LYNCH. Youngstown native Terence M. Lynch received his bachelor of arts and master of arts degrees in history in 1975 and 1977, respectively, from YSU. He worked for many years in Washington, D.C., serving on the staff of Alabama senator Richard Shelby and later as a lobbyist for Booz-Allen Hamilton. On September 11, 2001, Lynch had a meeting at the Pentagon; he lost his life when terrorists flew American Airlines flight 77 into the building. Lynch's wife, Jackie, and daughters Tiffany and Ashley, have turned their grief into a positive reaffirmation of his life by being generous supporters of YSU's history department.

CHRISTY CAMERON. When Christy Cameron came to YSU in 1996, the women's softball team had been at the bottom of the rankings nearly every season. Working hard to reverse that statistic, Cameron slowly improved the team's performance from winning just seven games in 2000 to near back-to-back 30-win seasons in 2003 and 2004. In 2003, Cameron was named Horizon League Coach of the Year. In 2006, the YSU women won the Horizon League championship.

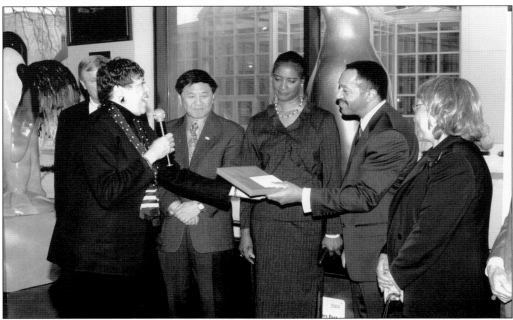

TONY ATWATER. Appointed in 2001, Dr. Tony Atwater became the first African American to hold the position of provost at YSU. He is pictured here (second from right) with his wife, Beverly (third from right), at his farewell party. Germaine Bennett of the Youngstown Board of Education, is handing him a gift; the Atwaters are surrounded by board of trustees members (left to right) John Pogue, Dr. H. S. Wang, and Millicent Counts.

PETE THE PENGUIN AND STUDENT. YSU is the only NCAA Division I school with the penguin as its mascot and team nickname. Adopted in January 1933, the penguin nickname supposedly originated at a very cold game with West Liberty, where YoCo fans flapped their arms to keep warm.

Poor Petey! Being Hen-Pecked

Patricia has arrived to the great joy of Youngstown college and Potey, her husband. But from the looks of things Patricia is going to wear the pants in that family.

Properly chaperoned, they were formerly introduced in the administrative office last Wednesday morning. At first sight there began a toad eye pecking skirmish with no sides winning and Petey retreating into a corner. Fearing she had frightened her man, Patty waddled over with due apo-

logies and made up Eskimo fashion.

Wishing to explore their new environment, they played follow the leader through the hall and into the lounge where they were greeted by their public. A Cook's tour was made with Nate Nateman acting as guide and protecting the co-eds bare legs from the pecking of Peter, the flirt. Occasionally they took pecks at each other, but when human hands threatened to interrupt their romance, Patricia placed a protective flipper around Pete.

PETE AND PATRICIA PENGUIN. As early as 1940, a live penguin named Pete lived at the college. Pete I came to an unfortunate end in 1941 when he drowned trapped under the ice while pursuing fish in Crandall Park on the city's north side. In November 1941, Youngstown College secured for Pete II a bride named Patricia Penguin. Rumor has it that Patricia wore the pants in the family and thoroughly henpecked (or penguin pecked?) her spouse. Petey, as he was called, died the following year at the Cleveland Zoo, where he made his second home. Patricia was also rumored to be ill at the time.

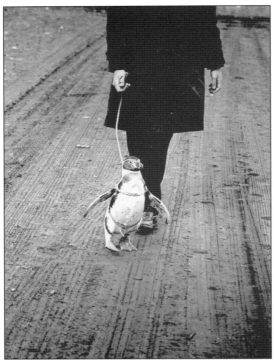

PETE THE PENGUIN. The last live penguin mascot came to YSU in 1967 from the Pittsburgh Zoo. Pete traveled with the football and basketball teams to their games. Unfortunately, Pete succumbed to illness at the age of eight in January 1972.

PETE AND PENNY PENGUIN. Following the demise of the living Pete Penguin, YSU opted for more traditional and longer-lived mascots, resorting to humans in penguin suits. Pete also remarried, choosing as his spouse the lovely Penny. Pete and Penny attend all the YSU football and basketball games as well as numerous community functions. Both Pete and Penny have become icons, recognizable throughout the Mahoning Valley. Recently they have been memorialized in the form of fire hydrants and Plexiglas penguin statues, which have been painted by local artists, similar to Chicago's cows.

Six

SPORTS

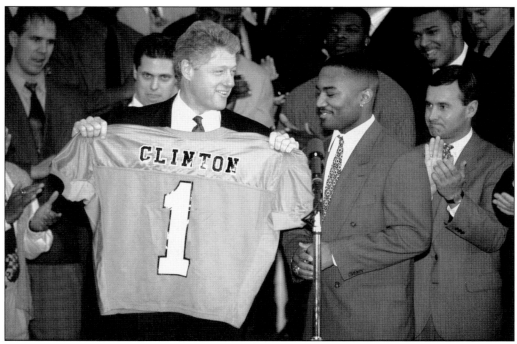

YSU Football Team Presents Jersey to President Clinton. Athletics at YSU have, from their inception, reflected the interest and enthusiasm of the greater community. Local supporters join YSU students and staff in supporting and celebrating its victories and accomplishments. YSU's tradition of athletic excellence prompted a White House invitation in March 1995, following the football team's second NCAA-1AA national championship. All-American in 1994, Lester Weaver is shown presenting a YSU football jersey to Pres. Bill Clinton. (Courtesy of William J. Clinton Presidential Library.)

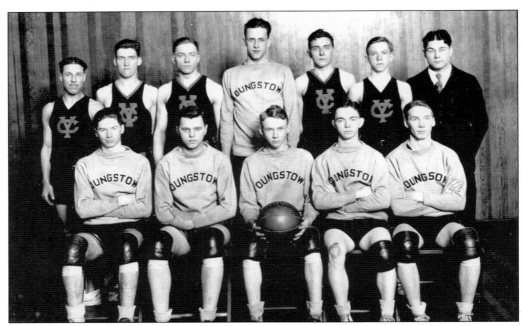

FIRST BASKETBALL TEAM, 1927–1928. YSU as a YMCA school meant that its earliest athletics were those played at the "Y." The school's first basketball team is seen here, sporting YC on their jerseys, although the name change to Youngstown College had not been formally acknowledged. The YC stood for "Wye-Collegian." At this early date, the YMCA usually referred to the liberal arts school as Youngstown College.

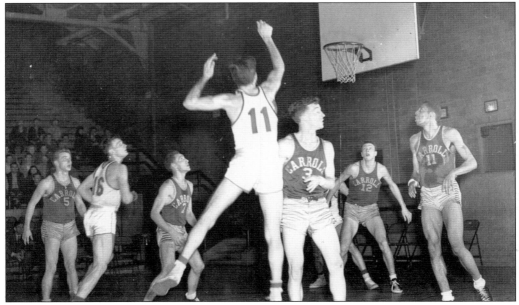

YOCO BASKETBALL GAME. In February 1949, Youngstown College played John Carroll, as seen in this photograph. During World War II, the college suspended men's intercollegiate sports for the duration. In the postwar years, athletics such as basketball enjoyed a resurgence at Youngstown College.

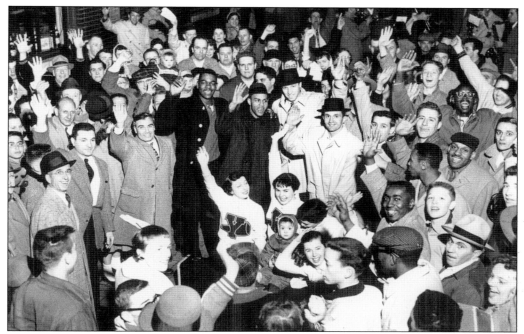

FANS GREET BASKETBALL TEAM. On March 17, 1957, an estimated 1,000 Penguin students and fans turned out at the Erie Railroad station in downtown Youngstown to greet their victorious basketball team. That year, the Penguins reached the quarterfinals of the prestigious NAIA tournament.

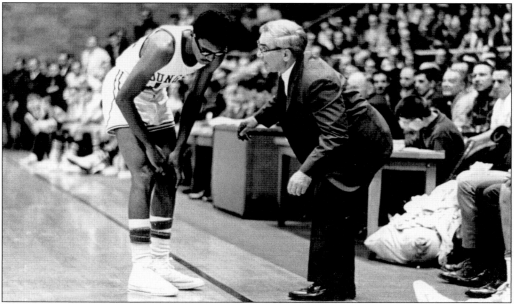

COACH ROSSELLI SPEAKING WITH JOHN MCELROY. Prior to the completion of Beeghly Center in 1970, the Penguin basketball team played either at Struthers Field House or South High School Field House. Dominic Rosselli, the longtime head coach, is seen here providing individual encouragement to John McElroy at a 1968 game.

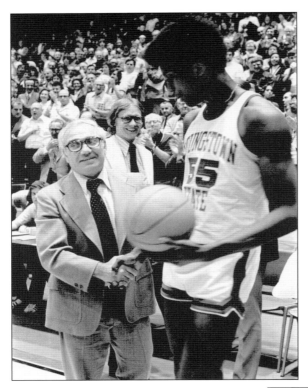

ROSSELLI'S 500TH VICTORY. The *Jambar,* in 1976, reported that Dom Rosselli won his 500th victory when YSU defeated Northern Kentucky University. When Rosselli retired in 1982, he had an impressive career record in all three sports he coached (basketball, football, and baseball) of 1,007-607. At the time of his retirement, he was ranked 10th in NCAA lifetime collegiate victories. In his 39 seasons as a coach, he recorded the second-most wins in NCAA Division II history.

KESTON ROBERTS GOING UP FOR A SCORE. The YSU men's basketball team won its 2006–2007 season opener against Slippery Rock University on November 19. Led by Keston Roberts, the Penguins cruised to victory 95-57.

Youngstown College Football in the 1930s and 1940s. In the closing years of the Great Depression and as the economic situation improved, residents of the Mahoning Valley began to look for greater diversions. With the establishment of the Youngstown College football team in 1938, local residents found an outlet for their enthusiasm. Howard Jones's daughter, Marilyn Jones Chuey, recalled, "When football started in 1938, there was curiosity probably more than anything else and an enthusiasm because we hadn't had any college football locally, and so the initial games were well attended. There were 10,000 at the first game."

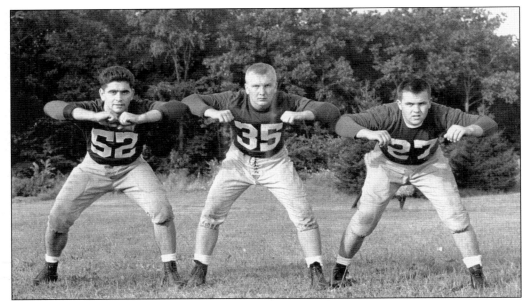

YOUNGSTOWN COLLEGE FOOTBALL, 1949. Following the end of World War II, Youngstown College football again assumed a position of importance at the school and in the community. In the late 1940s, the team was coached by Dike Beede (1938–1941). Seen here at football practice in 1949 are (left to right) John Arduino, Jack Bologna, and Francis Prazenica.

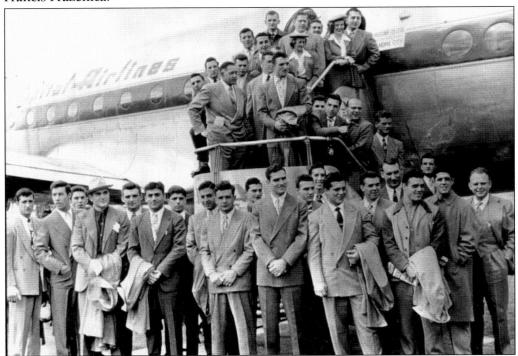

FOOTBALL TEAM LEAVING FOR OKLAHOMA. The Youngstown College football team is seen here in 1948 as they prepare to leave for a game in Oklahoma.

NIGHT GAME AT RAYEN STADIUM. For much of its history, the Youngstown College and University football teams played their home games at the Rayen High School stadium on the city's north side. This game was in 1959.

YOUNGSTOWN VERSUS AKRON. One of Youngstown University's main rivals was the nearby University of Akron. The intense rivalry made for exciting and fierce competition. Seen here is the 1960 version of that contest.

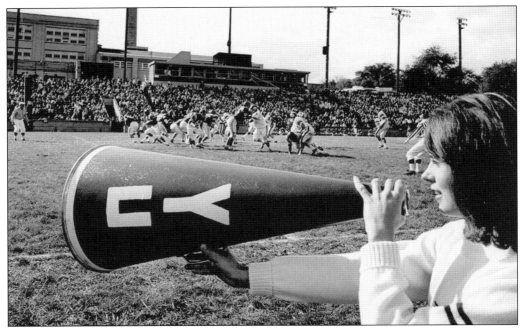

CHEERLEADER AT YOUNGSTOWN GAME. Cheerleader Tammy Taback is displaying school spirit at a football game in 1967. Note the YU on her megaphone, indicating that the university was still in the process of going state.

FOOTBALL GAME, 1977. Football at YSU was in a transitional period during the 1970s and early 1980s. Coach Beede retired after the 1971 season; he was succeeded by Ray Dempsey (1972–1975) and then Bill Narduzzi (1976–1985).

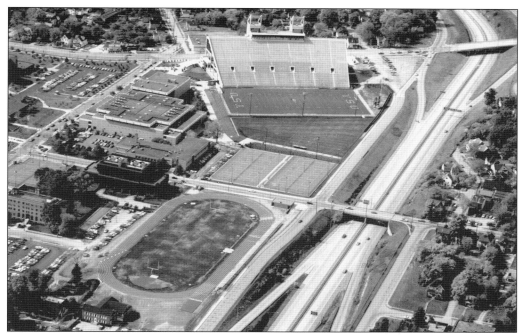

STAMBAUGH STADIUM UNDER CONSTRUCTION. In 1977, YSU began construction of its new football stadium, located on Fifth Avenue, at the north end of the campus. The facility opened in 1982, with a seating capacity of about 17,230.

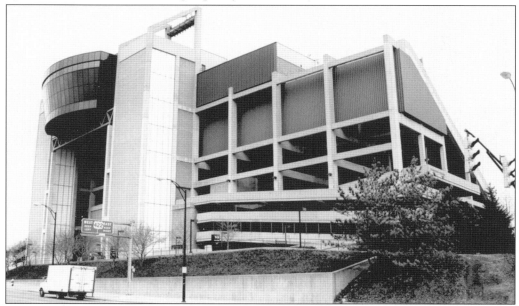

STAMBAUGH STADIUM. The immense popularity of YSU's home games created a need for a larger facility. In 1997, the east side of the stadium was completed, increasing its seating capacity to 20,630, making it one of the largest Division I-AA structures. Also known as the "Ice Castle," YSU Penguins have an impressive 83-12-1 record in the facility from the 1989 through 2005 seasons.

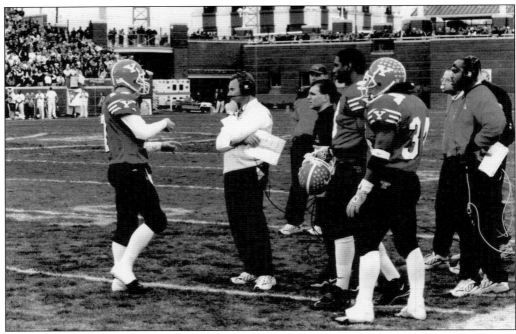

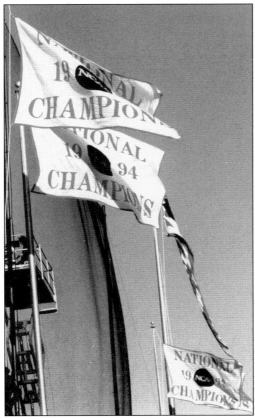

JIM TRESSEL ERA. The Jim Tressel era at YSU began in 1986, initiating an extraordinary run of football excellence, on and off the field. Tressel, prior to coming to YSU, was the quarterback and wide receiver coach at Ohio State. During his 15 years at YSU, he compiled an impressive record of 135-57-2, qualified for the 1-AA playoffs 10 times, and won an amazing four 1-AA national championships. His numerous honors include Chevrolet Coach of the Year in 1993, 1994, and 1997 and Ohio College Coach of the Year in 1989, 1990, 1991, 1994, 1997, and 1999. Pictured here are Jim Tressel at a game, and NCAA 1-AA championship flags fluttering over Stambaugh Stadium.

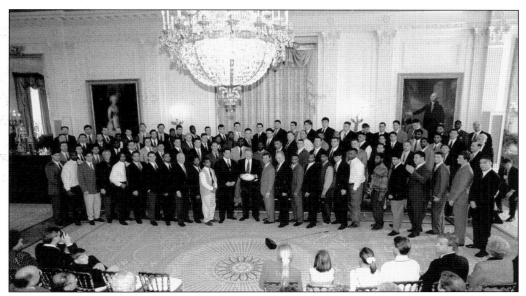

YSU Football Team Visits the White House. On March 6, 1995, the Youngstown State 1-AA championship team of 1994 made history. They were the first college or professional team in any sport from the state of Ohio to be invited to the White House. They were also the first Division 1-AA champions so honored. The top photograph is a team shot in the east room of the White House. The lower image depicts Jim Tressel and his team with Pres. Bill Clinton. (Both photographs courtesy of William J. Clinton Presidential Library.)

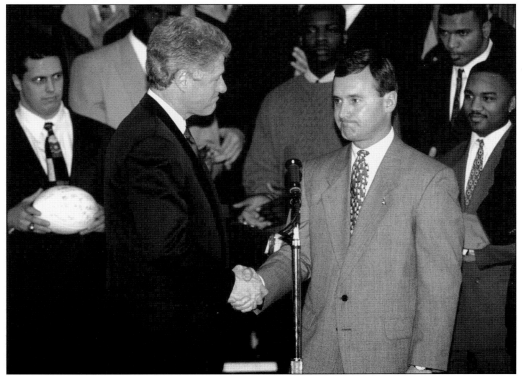

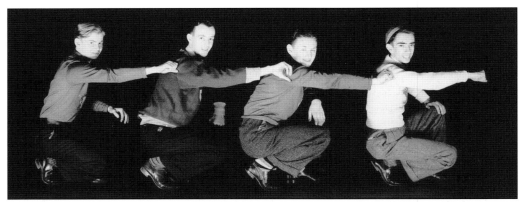

YOUNGSTOWN COLLEGE CHEERLEADERS. The cheerleading tradition at Youngstown is as old as the football team. Its initial squads were, however, composed of men rather than women. Pictured here are four cheerleaders in May 1938.

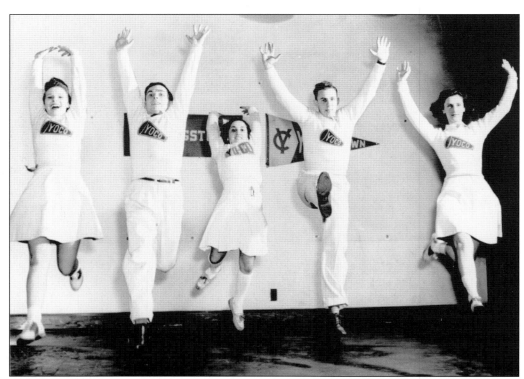

CHEERLEADERS IN THE 1940S. By the 1940s, cheerleading squads had both men and women. The group pictured here urged their team to victory at a basketball game.

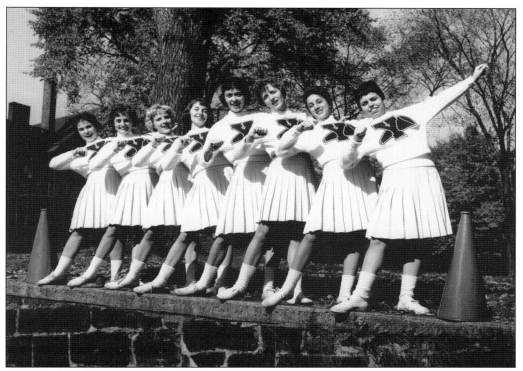

CHEERLEADERS. The presence of cheerleaders at YSU sporting events as well as other community activities continues to the present. The cheerleading squads, now composed mostly of women, are seen here in 1959 (above) and 2006.

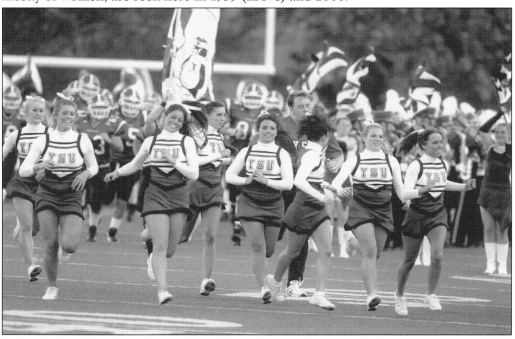

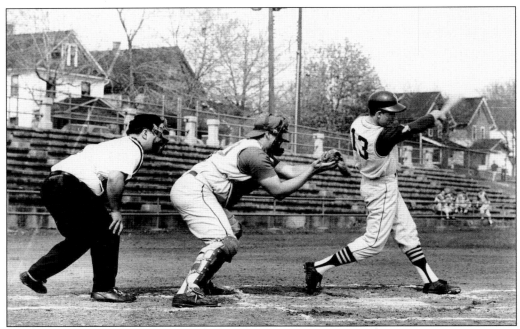

BASEBALL. Baseball at YSU dates back to 1948, when head basketball coach Dom Rosselli formed the school's first varsity baseball team. In 1958, the Penguins were the NAIA champions. The team is pictured here during a game around 1955.

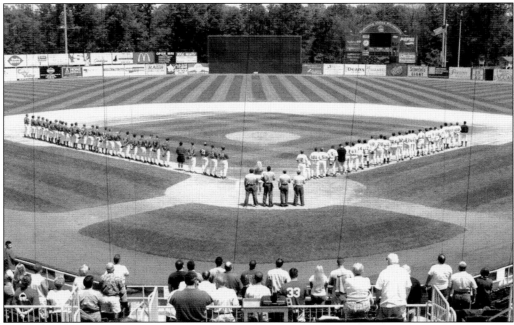

THE 21ST-CENTURY PENGUINS. America's pastime is still as popular as ever at the dawn of the 21st century, and YSU is no exception. The baseball Penguins are seen here at Eastwood Field, site of many of their home games. In 2004, YSU swept the Horizon League tournament with a 4-0 record, sending them to the Division 1 NCAA regionals.

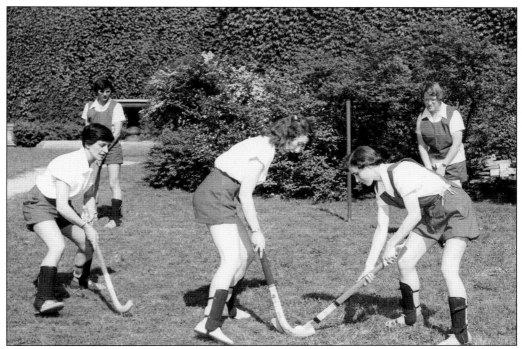

WOMEN'S ATHLETICS—THE EARLY YEARS. Women's athletics began relatively early in the history of YSU, due to the connection with the YMCA. In the period before Youngstown University became a state institution, the opportunity to participate in athletic endeavors was limited primarily to physical education classes and intramural competition. By 1939, the Women's Athletic Association was a functioning entity at the college and served as an umbrella to organize these activities. During the 1940s and 1950s, women participated in a variety of activities including volleyball, golf, and shuffleboard.

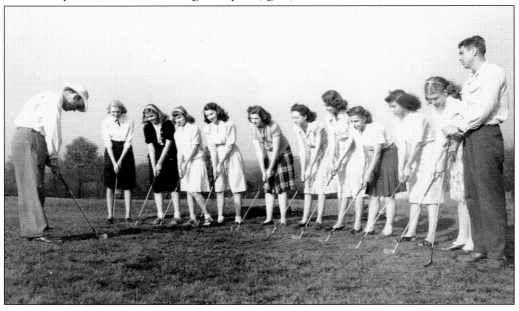

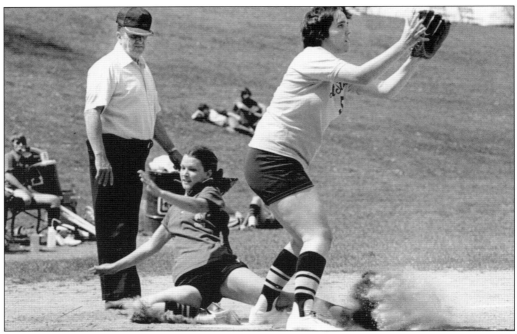

WOMEN'S VARSITY SPORTS. By the mid-1970s, women's varsity sports made their debut at YSU. Some of the first teams included basketball, softball, volleyball, field hockey, and gymnastics. The 1977 women's softball team swept the state championships. The gymnastic team won two consecutive Division II Midwest regional championships in 1973 and 1974. These images, both from the 1970s, show the variety in women's athletics and the influence of Title IX.

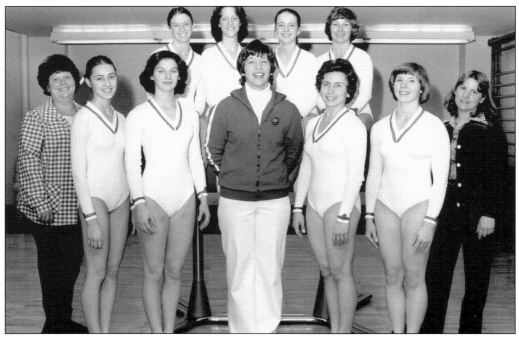

Seven

ACTIVITIES, ORGANIZATIONS, AND CELEBRATIONS

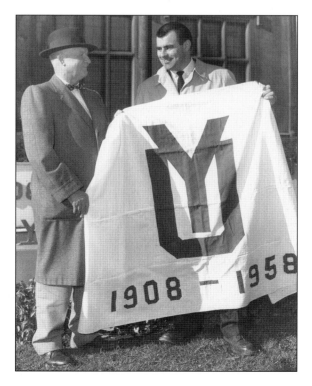

YOUNGSTOWN UNIVERSITY CELEBRATING ITS 50TH ANNIVERSARY. Students at YSU have a long history of participating in extracurricular activities and celebrations. The range of activities includes May Day events, formal dances, homecoming parades, music, theater, and various clubs. In this photograph, Howard Jones (on the left) and a student proudly display a flag commemorating the 50th anniversary of the founding of the institution. They are standing in front of the Main Building, later renamed in Jones's honor.

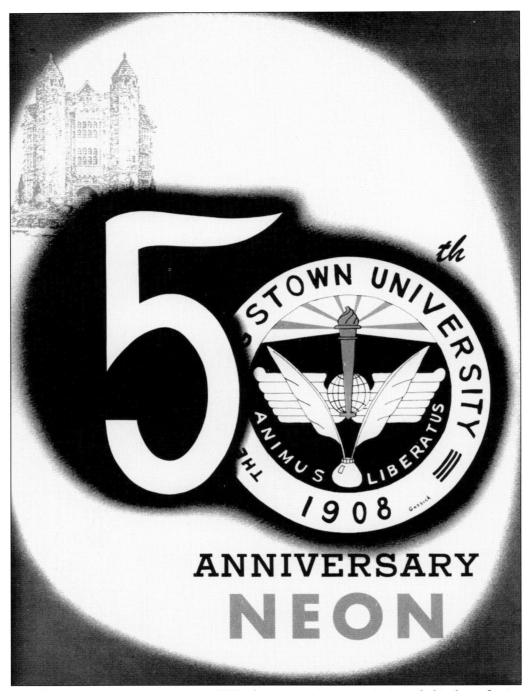

THE 50TH-ANNIVERSARY LOGO. In 1958, the university commissioned this logo for its golden anniversary.

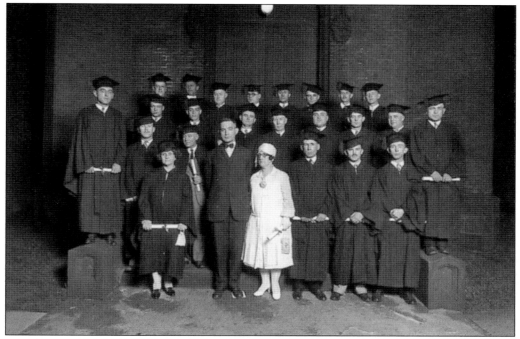

LAW STUDENT GRADUATES, 1927. Graduates of the 1927 law school class assemble after graduation. The 24 members of the class, which included two women, hold their rolled diplomas as they pose for the camera.

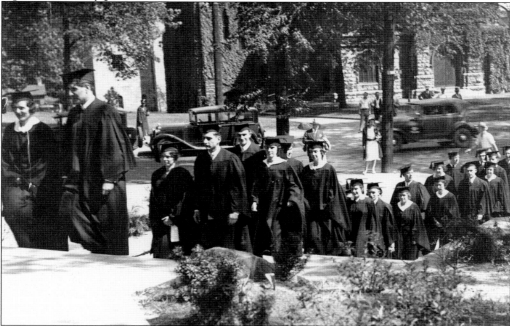

GRADUATES OF THE CLASS OF 1932. With great pomp, the members of the class of 1932 process into the Main Building. This was the first group to use the new facility for their commencement ceremony.

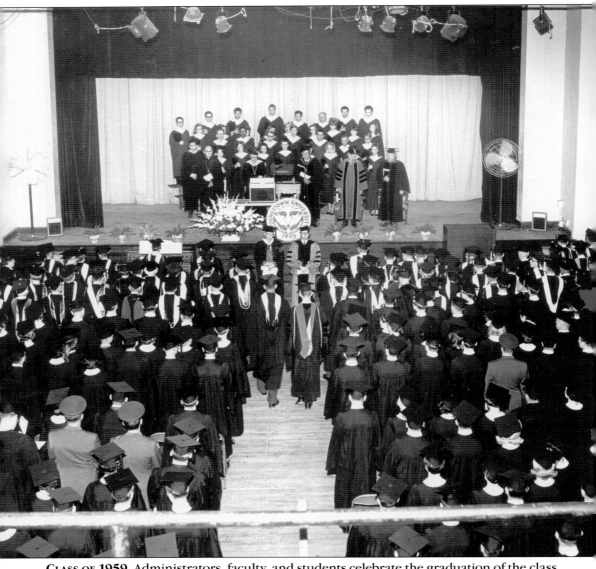

CLASS OF 1959. Administrators, faculty, and students celebrate the graduation of the class of 1959 in Strouss Auditorium, a 1949 addition to the Main Building. Take special note of the members of the class in military uniform.

THE FIRST MAY DAY FESTIVAL. May Day and the arrival of spring remained one of the leading celebrations on campus from its initiation in 1928 through the 1960s. The rites include a pageant, a maypole dance, and the coronation of the May Queen. In 1928, Mayor Joseph Heffernan of Youngstown escorted Ruth Taylor, the first May Queen. As part of the festivities coeds participated in the maypole dance in the photograph below.

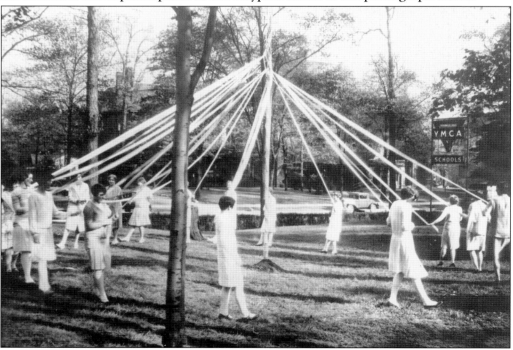

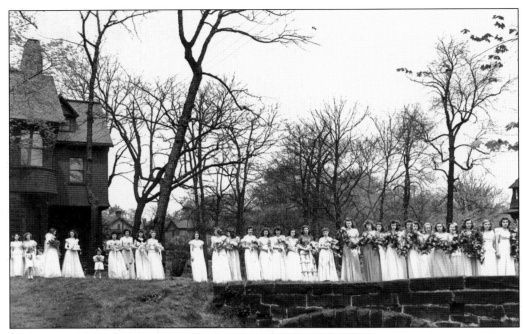

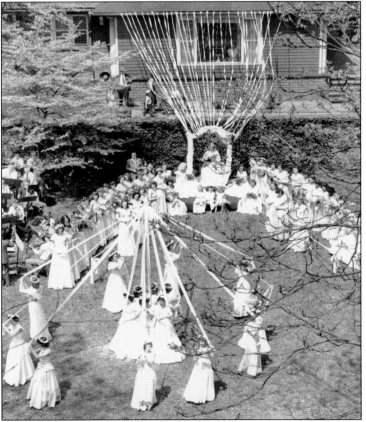

THE RITES OF SPRING IN THE 1940s. In the 1940s, the May Day events became more formal. Seen above are members of the May Queen's court in 1947 processing across the stone bridge between East Hall and the Henry Butler House. In this photograph, participants carry a chain of flowers as a symbol of the arrival of spring. In the late 1940s, spectators watch the rites of spring on the lawn between the Butler House and East Hall in the photograph to the left.

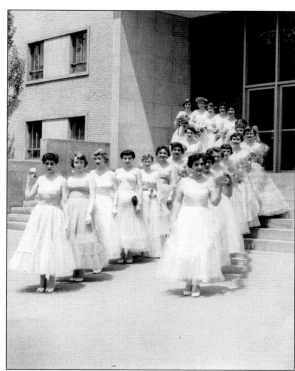

THE 1954 MAY CELEBRATION. May Day celebrants leave the newly constructed library in 1954 in the photograph to the right. As part of the procession, members carry two strands of the daisy chain. In the photograph below, members of the campus ROTC create an arch of crossed swords for the May Queen, Ruth Lanz, on her way to the coronation.

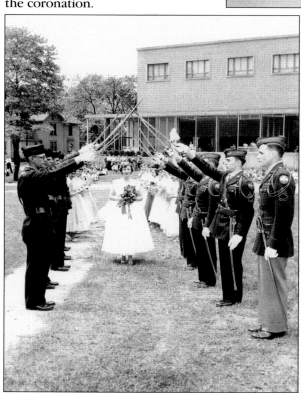

SADIE HAWKINS DAY. One of the most enjoyable and energetic events on campus was Sadie Hawkins Day, which began in 1934. Students dressed up in elaborate costumes and engaged in activities that were beyond the norm. On Sadie Hawkins Day, traditional gender roles are reversed, with the women asking the men out as well as proposing marriage. Youngstown students are seen here in the 1940s (above) and 1950s (below). County engineer Samual Gould is on the donkey. From left to right are Judy Millard, Marlene Betras, Theresa Capuzello, Vinnie Crips, Joan Ault, Gould, and Ed Evanuk.

UNIVERSITY CHOIRS. With the addition of the Dana School of Music to the Youngstown College curriculum in 1941, music programs at the school flourished. Choirs, orchestras, and other musical groups have been a staple of the institution since that time. These integrated Dana choirs are both from the 1950s. In the photograph on the right are Gordon Brooks at the organ and, from left to right are (first row) Dalia Vitucci, Mary Barganier, Alice Lee Wright, Sondra Borger, and Julie Karavara; (second row) Kelly Brandmiller, Jerome Toti, Everett McCollum, and James Penn. The photograph below is of the 1953 Christmas concert.

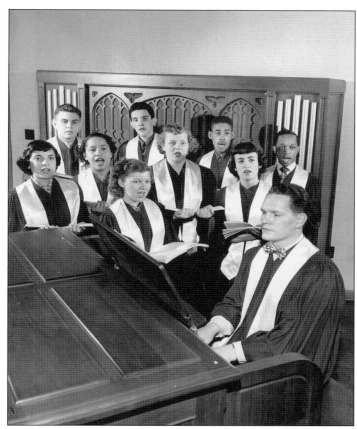

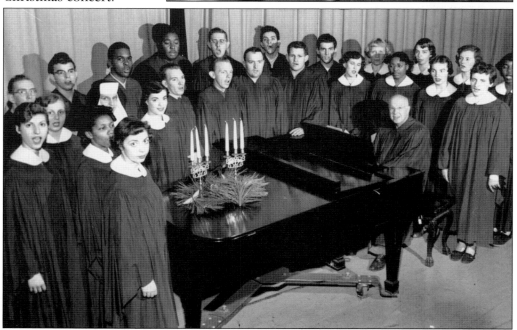

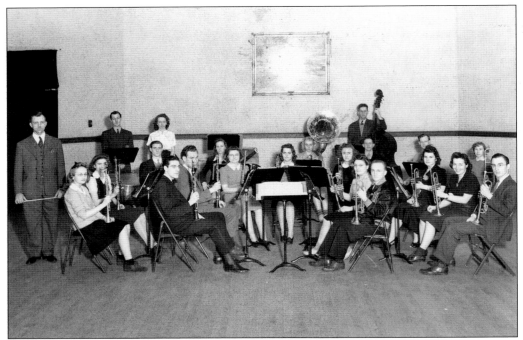

MUSICAL GROUPS. These two photographs depict Youngstown College musicians, both from the 1940s. The photograph above is of the concert band of 1942, and the photograph below is of a woodwind ensemble from 1949. The tradition of musical excellence continues through the present day.

DRUM MAJOR AND CHEERLEADERS.
The 1938 marching band featured
a drum major, posing here with
two cheerleaders in front of the
Main Building. The typical 1930s
costumes on the young women are
relatively modest outfits.

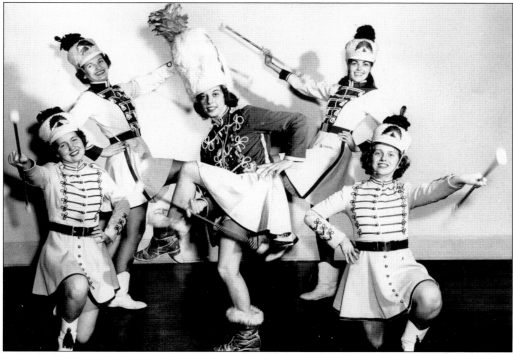

MAJORETTES. The marching band would not be complete without its majorettes. These young women from 1952 provide an energetic flair for the band as they strike poses with their batons. The head majorette (center) is identified by her large headgear.

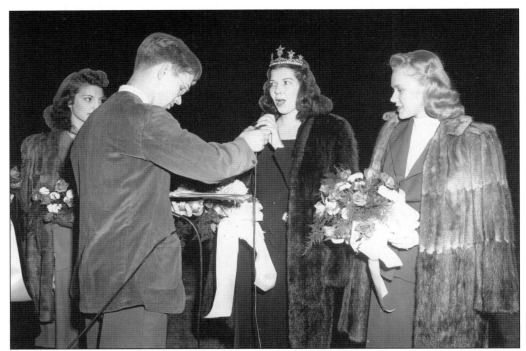

HOMECOMING. One of the biggest annual events at Youngstown College—which continues through to the present—is homecoming. The photograph above shows the 1947 homecoming queen Martha Altman and two members of her court. The photograph below depicts a *c.* 1955 homecoming queen and her court.

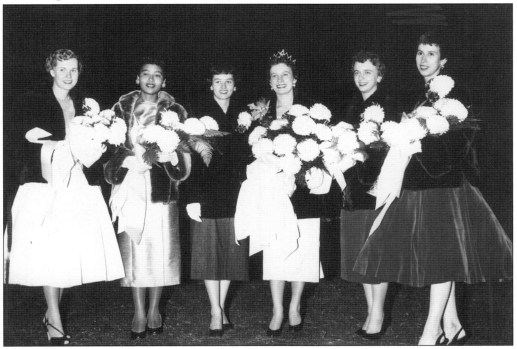

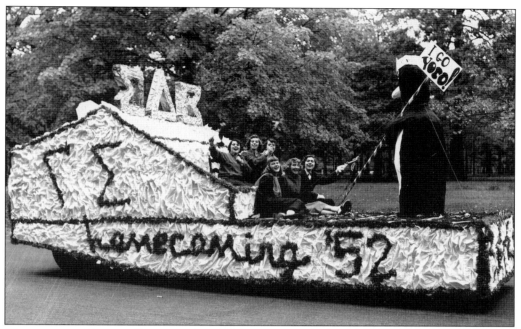

HOMECOMING FLOATS. Homecoming celebrations include a parade through downtown Youngstown. These two photographs are from 1952 (above) and the late 1950s (below). In the photograph below, note the background, which depicts some of the many commercial buildings that once existed on East Federal Street in downtown Youngstown.

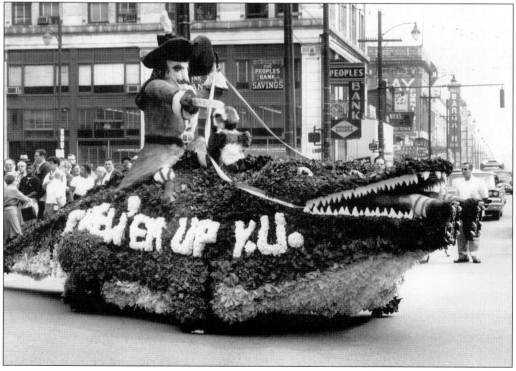

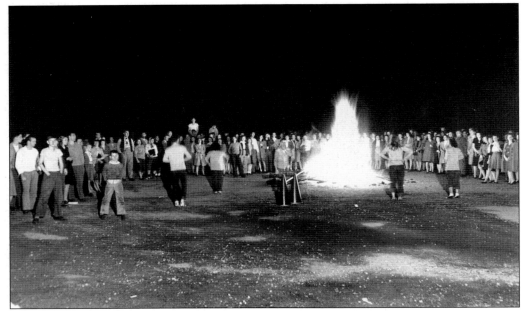

PEP RALLY. At the war's conclusion, students at Youngstown College were ready to celebrate again. In preparation for a big game on October 5, 1946, students are enjoying an evening pep rally complete with bonfire.

PEACE CARAVAN. On August 10, 1947, Youngstown College students met with the Peace Caravan. Pictured on the steps on the east side of the Main Building, students pose with members of the caravan and Pres. Howard Jones (center, with tie).

STUDENT COUNCIL. Youngstown College students engaged in a number of activities to prepare them for the "real world." Student council was, perhaps, one of the most important. Here is a working group pictured in 1947.

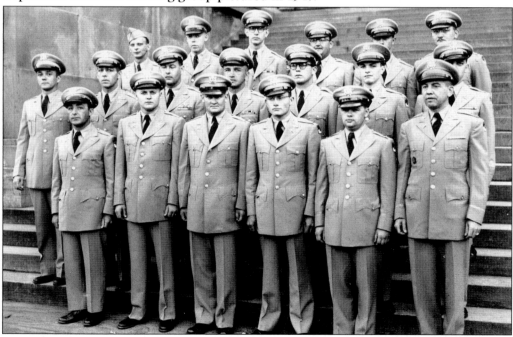

ROTC OFFICERS. Howard Jones brought the ROTC to Youngstown College in 1950. Its popularity reflected growing concerns about the cold war that engaged American society following World War II. The ROTC officers, pictured here, are from the 1950s and are posed on the steps of Stambaugh Auditorium. The program remained exclusively male until 1973.

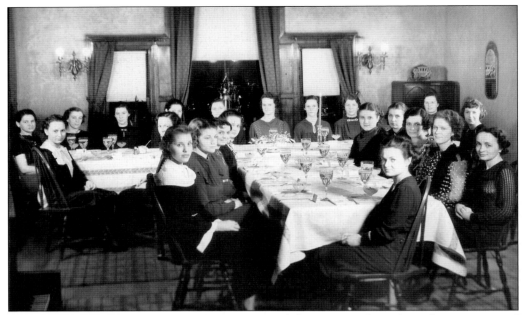

ALPHA IOTA SORORITY BANQUET. Sororities and fraternities have long been a part of Youngstown's college life. The Alpha Iota sorority held a dinner banquet in 1935. Note the formality of the event.

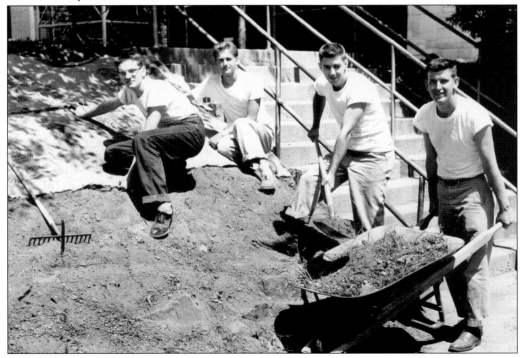

SIGMA RHO FRATERNITY. Service to the college and the community traditionally have been important parts of Greek life on campus. Members of the Sigma Rho fraternity lend their hands to the beautification of the campus landscape in 1955.

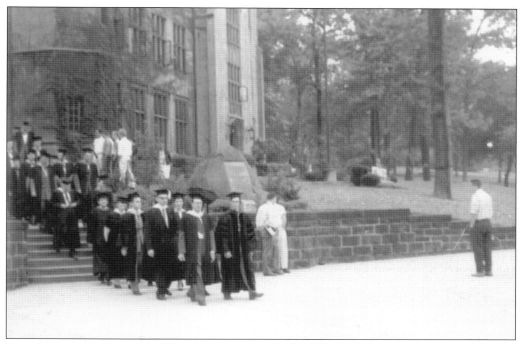

YOUNGSTOWN UNIVERSITY'S 50TH ANNIVERSARY. In the fall of 1958, Youngstown University began the celebration of its golden anniversary. The faculty and administrators processed out of the Main Building (above) and marched south down Wick Avenue toward downtown. In the photograph below, they are entering the Palace Theater for a recognition ceremony.

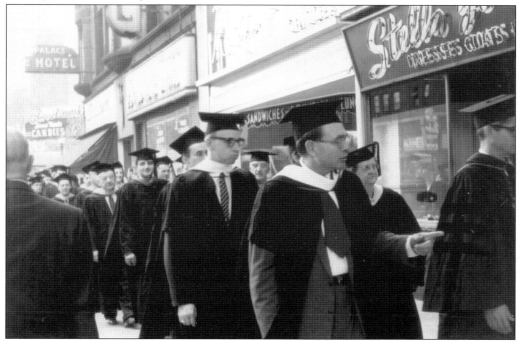

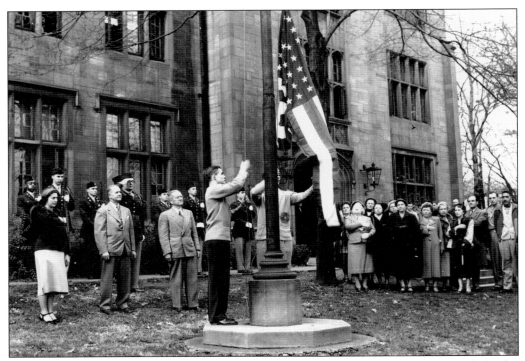

THE 50TH ANNIVERSARY EVENTS. Youngstown University marked its 50th birthday by raising the American flag next to the Main Building (above). In honor of the occasion, the homecoming parade of 1958 also featured floats commemorating the event, similar to the one seen in the lower photograph.

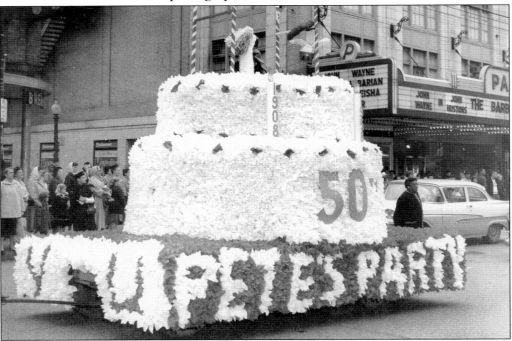

Eight

To the
Second Century

Youngstown State University Logo. In 1967, as Youngstown University neared its 60th birthday, the board of trustees and the Ohio Board of Regents approved the school's transition into the state system. At its centennial and beyond YSU will continue to be a vital and integral member of its community. When Youngstown University went state in 1967, the school updated its logo to reflect that change.

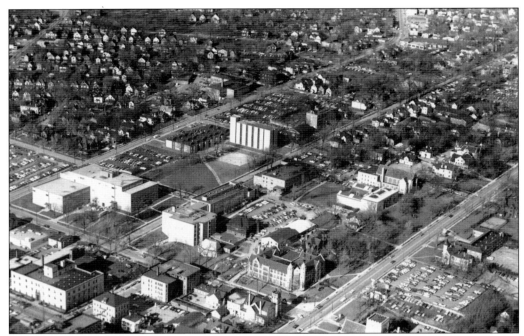

GROWTH OF YSU. The aerial view of the campus in February 1968 (above) gives an idea of the campus layout at the time the school went state. The main part of the campus remained bordered by Wick Avenue to the east and Lincoln Avenue to the south. Campus development had not yet moved west of Elm Street, and the Madison Avenue Expressway had yet to be started. The lower image shows the YSU campus as was envisioned in 1970. The university had moved its western boundary to Fifth Avenue and showed evidence of an aggressive new building campaign.

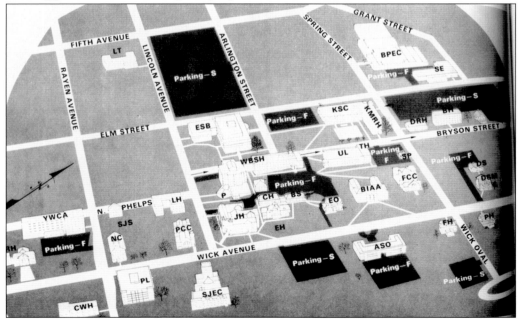

DEDICATION OF ENGINEERING BUILDING.
One of the first new structures
completed for the newly minted YSU
was the engineering building, now
known as Mosher Hall. Seen here at
the 1968 dedication are, from left to
right, Mrs. James L. Fisher, mayor of
Youngstown Anthony B. Flask, YSU
president Albert L. Pugsley, Ohio
governor James A. Rhodes, Dr. Albert F.
Doolittle, dean of engineering M. Jean
Charignon, and former university
president Dr. Howard M. Jones.

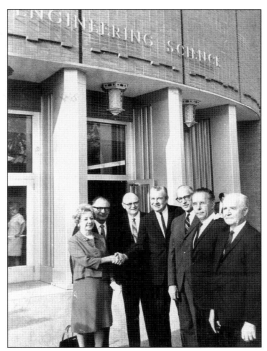

WILLIAMSON HALL. Originally known as Lincoln Project, the Williamson College of
Business Administration was built on the site of the old Lincoln Hotel. Its rapid
planning and construction reflects aggressive university growth and the spread of the
campus boundaries.

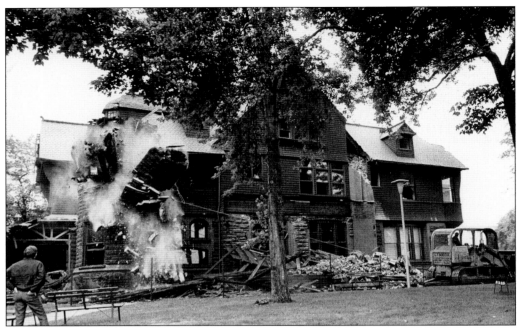

RAZING EAST HALL. The late 1960s and 1970s were a transitional time for the campus, as it moved out of older residential buildings and built structures more suitable to the institution. In 1972, YSU razed East Hall, the former Henry C. Wick property, as well as the Henry Butler house in preparation for the construction of the new library. West Hall, which was originally Henry Wick's carriage house, was also razed. In the 1960s, prior to its demolition, West Hall housed male African American student athletes.

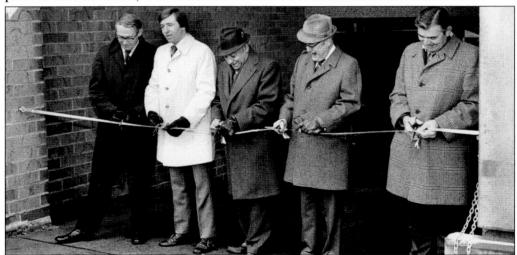

DEDICATION OF LINCOLN AVENUE PARKING DECK. Throughout most of its history, YSU was a commuter school and parking was a perennial problem. To alleviate some of the parking issues, the university constructed the four-level Lincoln Avenue parking deck in 1972. In the photograph, from right to left, are YSU vice president John Coffelt, YSU president Albert Pugsley, and Youngstown mayor Jack Hunter. They are cutting the ribbon barring the entrance to the new deck.

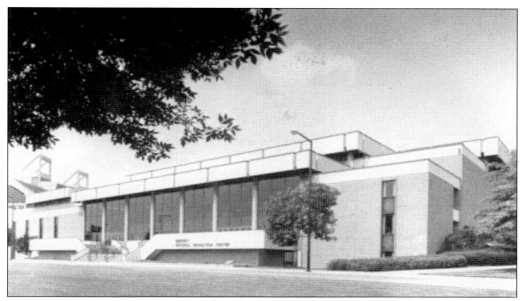

BEEGHLY HEALTH AND PHYSICAL EDUCATION CENTER. Construction on Beeghly Center began in 1969. The new facility was state of the art, with an Olympic-size swimming pool, a spacious gymnasium complex, a dance studio, exercise rooms, racquetball and squash courts, classrooms, weight rooms, and offices. It also housed most of the university's athletic programs until the construction of Stambaugh Stadium 10 years later.

MAAG LIBRARY, *c.* 1976. With its growing student population and faculty, YSU desperately needed a new library. The university raised sufficient funds to do so and began construction of the building in 1975. Dedicated to William F. Maag, founder of WFMJ radio and television station and publisher of the *Vindicator*, the library is an example of brutalism, an architectural style popular in the 1960s and 1970s, which celebrated its concrete construction composition.

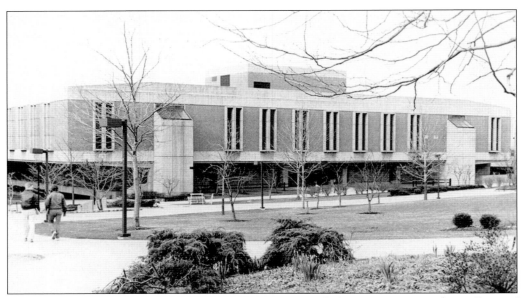

COLLEGE OF APPLIED SCIENCE AND TECHNOLOGY. Originally known as CAST, the College of Applied Science and Technology is now known as Cushwa Hall. It was completed in 1976 and renamed two years later in honor of Charles B. Cushwa Jr., Youngstown industrialist and former chair of the YSU board of trustees. The photograph is from 1978.

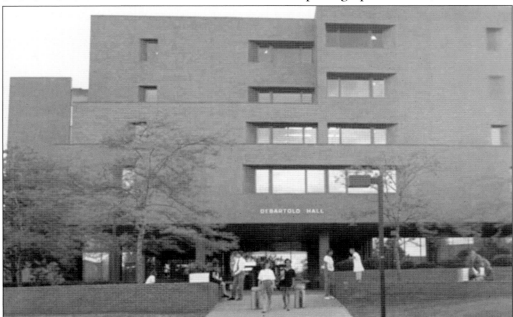

DEBARTOLO HALL. For many years, a number of the College of Arts and Science departments were housed in the old Valley View Motel on the east side of Wick Avenue, directly across from the Butler Institute. Completed in 1977, this building is named for one of the area's leading shopping mall developers and Youngstown native Edward J. DeBartolo Sr. It houses the offices of the College of Arts and Sciences and eight departments as well as classrooms and computer laboratories.

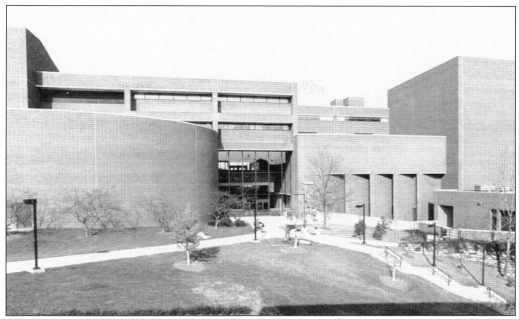

BLISS HALL. The College of Fine and Performing Arts moved into its new home on Wick Avenue in 1976. Bliss Hall is named for William E. and Fern Bliss, Youngstown philanthropists. It underwent a major renovation and expansion in the early 21st century and reopened for use in 2003.

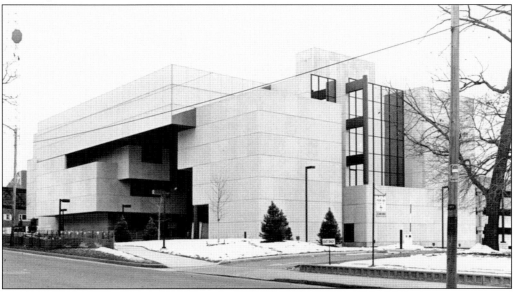

MESHEL HALL. State senator Harry Meshel, a YSU alumnus and vocal supporter for funding of the institution in the Ohio Senate, was honored with a new building named for him. It was completed in 1986, and Gov. Richard Celeste attended the dedication of the building, which houses YSU's information technology facilities, and registrar and bursar offices, as well as the Department of Computer and Information Science. The building sits in front of the Wick Avenue parking deck constructed in 1978.

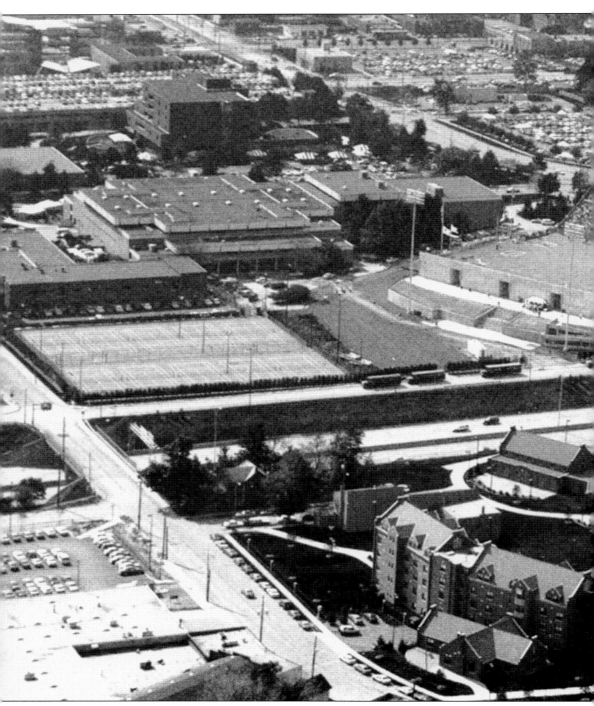

AERIAL VIEW. In the 1980s and 1990s, YSU expanded its boundaries to the north with the beginning of the construction of Stambaugh Stadium in 1982. Lyden House, the first dormitory built on campus since going state, began construction in 1989. In 1995, Cafaro House, a dormitory for the University Scholars and honors students opened

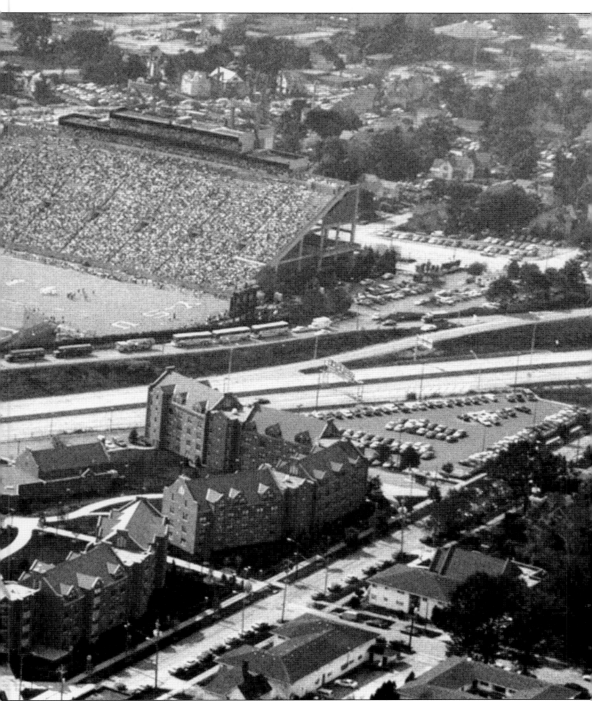

next to Lyden House, pictured at the bottom of the photograph. The following year, the commons area between the two dormitories, where the dining area is located, was named the Christman Campus Commons after Anna Kilcawley Christman, who donated $500,000 to the project.

BEEGHLEY COLLEGE OF EDUCATION. One of the fastest-growing colleges at YSU, the Beeghley College of Education outgrew its old facility in Fedor Hall. Named for Leon Beeghley, the new Beeghley Hall opened in 1998.

ANDREWS STUDENT RECREATION AND WELLNESS CENTER. Largely funded by private donations, YSU opened the Andrews Recreation and Wellness Center in the fall of 2005. This state-of-the-art facility contains exercise equipment; a weight room; courts for basketball, handball, and racquetball; meditation rooms; an indoor track; and a 53-foot-high climbing wall.

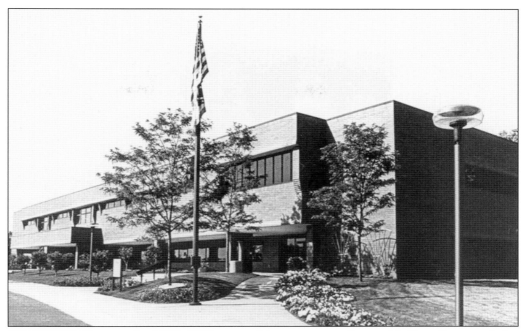

NEOUCOM CAMPUS. In 1972, YSU entered into a consortium with Kent State and the University of Akron forming the Northeastern Ohio Universities College of Medicine (NEOUCOM). The program allows students to accelerate their progress through medical school by combining a bachelor's program with that for the medical degree in five to six years. The campus is located 30 miles west of Youngstown in Rootstown.

ANGELA LEUNG ROBERTS. Dr. Leung Roberts is a 1999 graduate of NEOUCOM. She did the undergraduate portion of her work at YSU and then moved to the Rootstown campus at the end of her second year. Her decision to return to the area in practice truly illustrates the ultimate goal of NEOUCOM: to train physicians and pharmacists to serve the northeastern Ohio region.

HONORS PROGRAM. Introduced by Pres. Leslie Cochran, the University Scholars program has brought a number of bright young men and women to YSU. Recruited from the tops of their high school graduating classes, 40 students are selected each year and receive a full scholarship package, including on-campus housing and books. Honors and University Scholars are offered the opportunity to live in Cafaro House, rated nationally as one of the best honors residence facilities.

DOCTORATE IN EDUCATION. YSU's Beeghley College of Education began accepting students in its new doctor of education program in the mid-1990s. The new degree program fills a need of local educators who wish to receive the terminal degree in their field. Candidates are required to have served in kindergarten through grade 12 educational facilities prior to application. Pictured here receiving their doctoral hoods in 2006 are Maureen Donofrio (above) and Ben McGee.

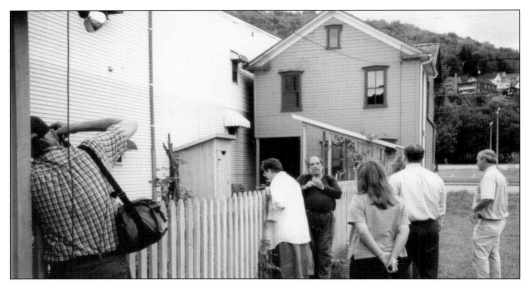

CENTER FOR APPLIED HISTORY. The Center for Applied History at YSU offers an interdisciplinary approach to the field of applied history. Designated as a YSU Presidential Academic Center for Excellence in Research (PACER), it serves as the community outreach agent of the Applied History Program, a certificate program in the Department of History, designed to meet the needs of students who wish to use their history training in the field. Since its formation in 1998, the center has completed numerous projects including nominations to the National Register of Historic Places. The center also houses the university's oral history program, one of the oldest and largest such programs in the region. Students in the program, seen here, are on a field trip to Johnstown, Pennsylvania.

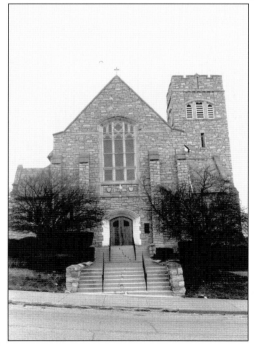

CENTER FOR URBAN AND REGIONAL STUDIES. The Center for Urban and Regional Studies plays an important role linking YSU with the greater Youngstown community. The center holds workshops, conducts surveys, assists in city planning, and provides professional assistance in urban planning. The Sacred Landmarks Initiative, which is a joint partnership with Cleveland State University, Kent State University, the University of Akron, Lorain County Community College, and Ursuline College, seeks to locate and preserve religious and sacred structures, such as Sacred Heart Catholic Church on Youngstown's east side, seen here. In 2004, the center received a prestigious Getty Campus Heritage grant for $100,000, in conjunction with the Center for Applied History.

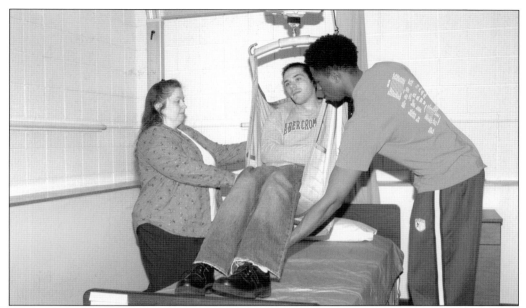

NURSING PROGRAM. Nursing studies at YSU underwent revitalization in the 1990s. Offering a bachelor of science and a master of science in nursing, the university became the major supplier of nursing personnel for the region. In 2006, Anthony and Phyllis Cafaro donated $100,000 to the nursing department in memory of Betty Nohra, nurse and wife of former YSU trustee and Cafaro Company executive Joseph Nohra. The money was to improve laboratory and technology facilities. Pictured here are students and faculty at work in one of the nursing laboratories.

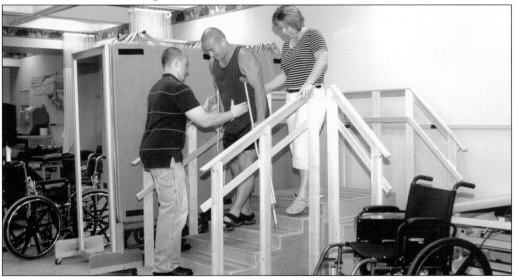

MASTER OF PHYSICAL THERAPY PROGRAM. The physical therapy program, introduced at the undergraduate level in the 1990s, now has a master's component. Designed as a three-plus-three program, students entering at the undergraduate level can obtain their master of physical therapy in six years. Pictured above are participants in the program, practicing their new skills in the laboratory setting.

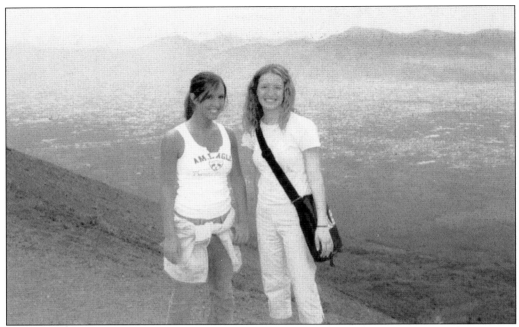

STUDY ABROAD. A number of YSU programs offer the opportunity for students to study abroad. The recently reorganized Center for International Studies facilitates students and faculty as they travel around the world. Members of the YSU family have visited and studied in such exotic places as the Bahamas, Russia, Poland, Israel, China, and Greece. Seen here are photographs from a 2005 study trip to southern Italy. At the top are two of the students in the program, Laura (left) and Sara Schaefer atop Mount Vesuvius with Naples in the background. In the lower photograph, students are pictured in front of an ancient Greek temple at Paestum, Italy.

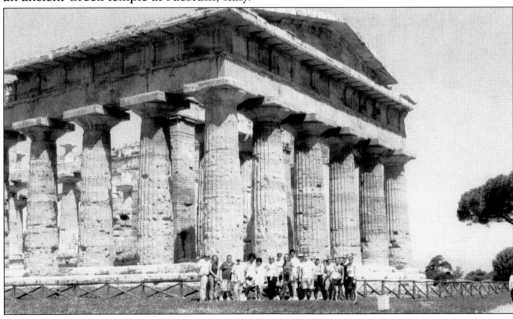

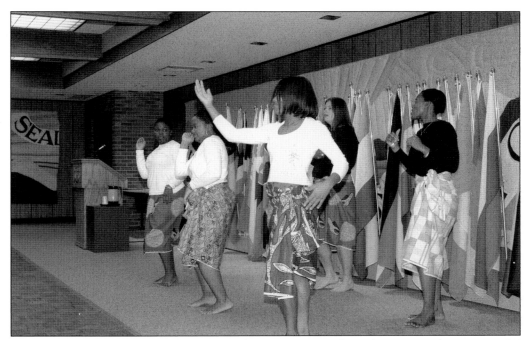

INTERNATIONAL STUDENTS. The Center for International Studies not only assists YSU students in studying abroad, it also facilitates foreign students who wish to study at YSU. In addition, the center houses the English as a Second Language program to assist non-English-speaking students as they adapt to an American collegiate institution. There are several on-campus organizations for international students, and a lounge in the student center funded by the LaRiccia family. The two photographs present students in costumes from their native countries.

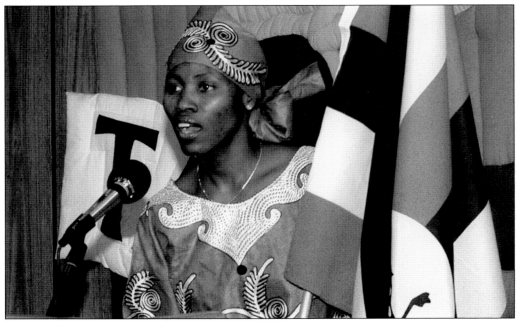

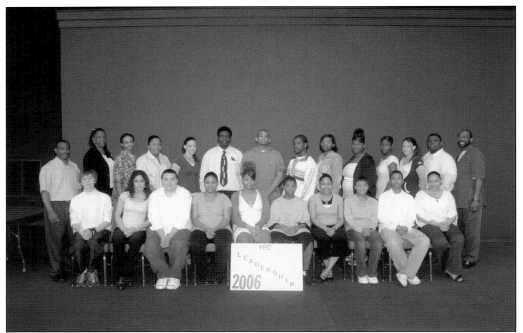

YOUNGSTOWN EARLY COLLEGE. Midway through its third year, the Youngstown Early College (YEC) makes its home in Fedor Hall at the north end of the campus. The program is designed to foster the development of Youngstown city public high school students considered at risk. Opening its doors in 2004, under Dean Larry Johnson, YEC requires student applications and engages the participants in a rigorous academic program. It has been a success story for both YSU and the Youngstown City Schools.

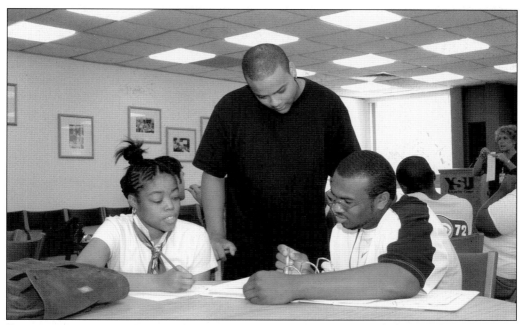

BRIDGE PROGRAM AND CENTER FOR STUDENT DEVELOPMENT. Pictured above are participants in the summer Bridge Program, whose purpose is to facilitate the transition of students from the high school into the university setting. Its focus is on traditional age multicultural students and aims at improving their success rates at the university and introduces them to the social and academic experiences at YSU. The Bridge Program is a part of the Center for Student Development. Seen below is coordinator of multicultural student services Michael Beverly, a YSU alumnus, with students at an information fair in Kilcawley Center.

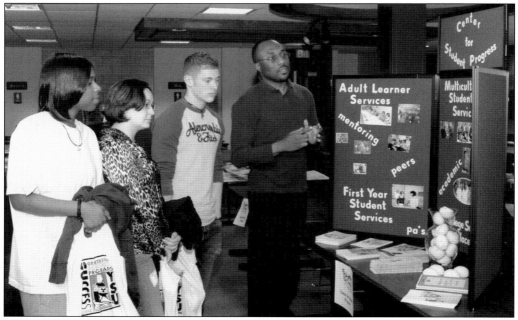

YSU IN THE SCIENCES. In the 1990s, YSU made a concerted effort, under the guidance of graduate dean Dr. Peter Kasvinsky, to increase grant monies. Since that time, the sciences have been enormously successful in their efforts, raising millions of dollars from agencies such as the National Science Foundation. Students are often involved in the projects, even as undergraduates. Pictured above are two chemistry students, Basit Alhassan and Jen Patton, with an x-ray defractometer. Seen below is Dr. Patrick Durrell, director of the planetarium, at an observatory on the island of Hawaii.

SOAR. Student Orientation and Registration (SOAR) provides incoming students with an introduction to YSU. Run by the Office of Admissions, the program utilizes personnel from the faculty, advisor's offices, and students. Seen here are peer assistants and guides who make up an important component of the program.

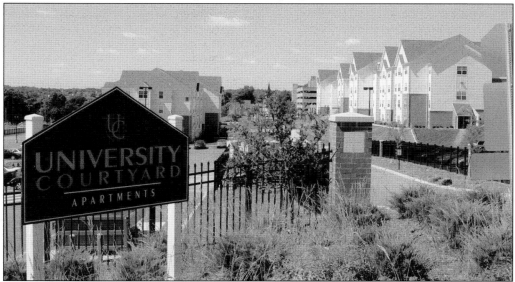

UNIVERSITY COURTYARD APARTMENTS. The Courtyards, as they are known, opened in the fall of 2003 to full-capacity occupancy. Providing an alternative to traditional dormitory life, they nearly doubled the amount of on-campus housing available to YSU students. The Courtyards are located east of Wick Avenue, in Smoky Hollow, which was once an ethnic working-class neighborhood. The university has in development, along with Wick Neighbors, plans for further redevelopment of Smoky Hollow.

CENTENNIAL CAPITAL CAMPAIGN. In 2006, YSU kicked off its Centennial Capital Campaign to raise $43 million in five years. The Williamson family, founders of WKBN radio and television, donated $5 million to kick off the campaign. The money is earmarked for the construction of a new Williamson College of Business Administration. Seen in this photograph are (left to right) J. D. Williamson, Lowry Stewart, Susan Brownlee, Warren P. Williamson IV, Lynn Williamson, and Warren P. Williamson III.

PLANETARIUM RENOVATION. Constructed in the late 1960s, the YSU planetarium underwent a $750,000 renovation, which was completed in the fall of 2006. Eleanor Beecher Flad, pictured here with the new digital SciDome projector system, was a major donor to the project, along with the Ward Beecher and Florence Simon Beecher foundations.

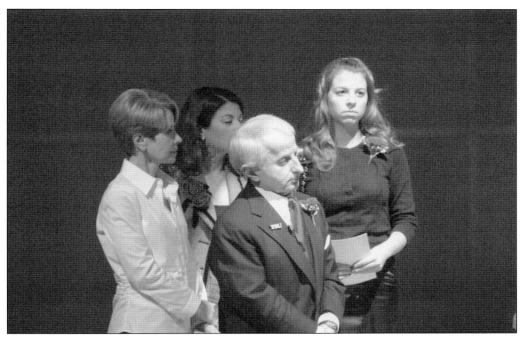

LARICCIA FAMILY. November 2006 saw a second major donation to the Centennial Capital Campaign. Tony and Mary Lariccia donated $4 million to the university; the money was earmarked for the establishment of the Lariccia School of Accounting and Finance in the Williamson College of Business Administration. Pictured here (above) is the Lariccia family, Mary and Anthony with daughters in the background; below is YSU president David Sweet, acknowledging the gift from the Lariccias.

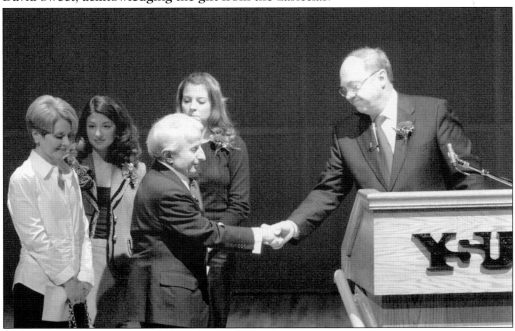

YSU Rocks! One of YSU's oldest traditions is the painting of the large rock, located in a place of honor in the central campus core. Although the rock has been relocated, it has never strayed more than 100 yards from its current location. Student groups are permitted to paint the rock to commemorate events, organizations, and special anniversaries.

JON HEACOCK. Leading the YSU Penguin football team in the 21st century, Jon Heacock carries on the winning tradition of his predecessors. In the 2005 season, his team won a share of the Gateway Conference title. The following year, the football team won the Gateway Conference championship outright and earned a number four seed in the NCAA Division 1 championship series. The 2006 team succeeded in reaching the semifinal game with Appalachian State.

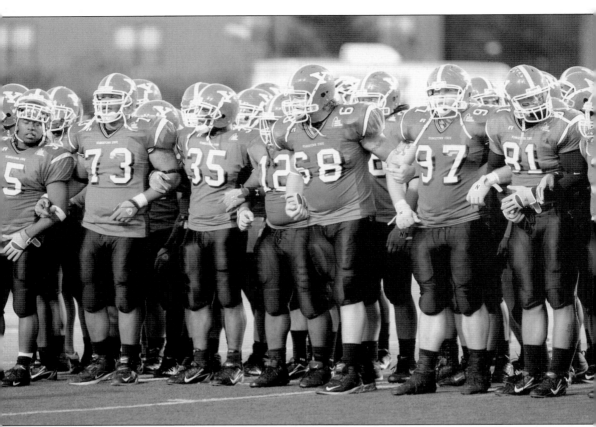

THE 2006 YSU FOOTBALL TEAM. In its first-round playoff game against James Madison, the 2006 Penguins, under coach Jon Heacock, upset the Dukes in a come-from-behind fourth-quarter victory. Playing in the "Ice Castle," the team rallied to defeat their opponents by a score of 35-31, thus moving on to the quarterfinal round against Illinois State. In that round, YSU defeated their opponent by a score of 28-21, moving on to the semifinal against Appalachian State.

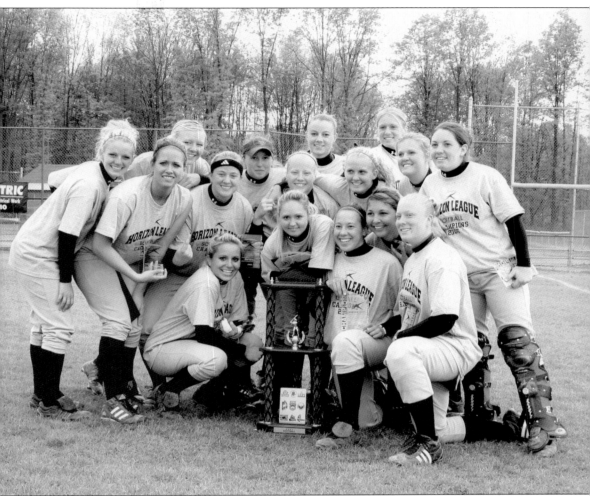

THE 2006 HORIZON LEAGUE SOFTBALL CHAMPS. Coach Christy Cameron led the YSU softball team to the 2006 Horizon League Championship. The team posted a Horizon League record of 10-10, which sent them to the NCAA tournament.

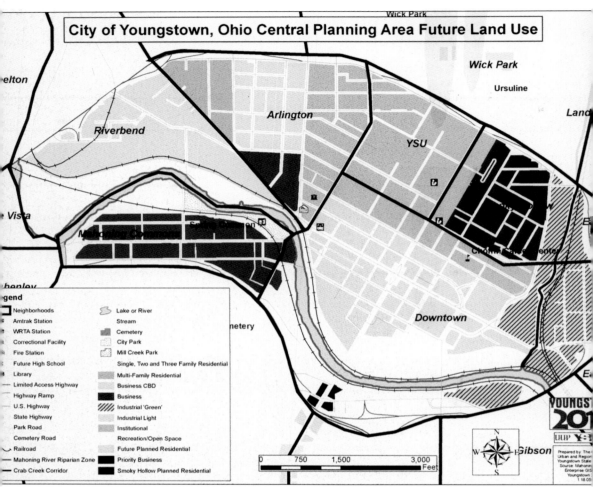

City of Youngstown, Ohio Central Planning Area Future Land Use

Wick Park

elton

Wick Park

Ursuline

Arlington

Land

Riverbend

YSU

Vista

Mahoning Commons

Downtown

henley

Legend

Neighborhoods		Lake or River	
Amtrak Station		Stream	
WRTA Station		Cemetery	
Correctional Facility		City Park	
Fire Station		Mill Creek Park	
Future High School		Single, Two and Three Family Residential	
Library		Multi-Family Residential	
Limited Access Highway		Business CBD	
Highway Ramp		Business	
U.S. Highway		Industrial 'Green'	
State Highway		Industrial Light	
Park Road		Institutional	
Cemetery Road		Recreation/Open Space	
Railroad		Future Planned Residential	
Mahoning River Riparian Zone		Priority Business	
Crab Creek Corridor		Smoky Hollow Planned Residential	

0 750 1,500 3,000
Feet

Gibson

YOUNGSTOWN 2010. YSU is playing a crucial role in planning for the city of Youngstown's future through the Youngstown 2010 Plan. The city and the university coordinated the planning process with nearly 200 volunteers. The plan delineates a new vision for the city based on the following four principles: accepting that Youngstown is a smaller city, defining its role in the new economy, improving its image and quality of life, and developing an achievable plan of action. Youngstown 2010 provides a comprehensive vision of a new Youngstown, built on its rich heritage, significant resources, and hardworking population. YSU, in its second century, is key to the success of Youngstown 2010 and the future of the former steel city.

STATUE OF HOWARD JONES. In late 2006, YSU commissioned a statue of the college's first president, Dr. Howard Jones. Tony Lariccia donated $100,000 for the new artwork, which will be located on the YSU campus in time for the centennial in 2008. The members of the sculpture selection committee chose this design by California sculptor Bruce Wolfe. It depicts Dr. Jones walking down a flight of steps.

Pete the Penguin. Once a Penguin, always a Penguin.

BIBLIOGRAPHY

Butler, Joseph G. *History of Youngstown and the Mahoning Valley, Ohio*. 3 vols. Chicago and New York: American Historical Society, 1921.

Gillespie, P. Ann. "Wick Avenue, 1940-1967: Millionaire's Row and Youngstown State University." Unpublished master of arts thesis, Youngstown State University, 2006.

Skardon, Alvin. *Steel Valley University: The Origins of Youngstown State University*. Youngstown, OH: self-published, 1983.

Youngstown State University Oral History Program. Interviews from the history of Youngstown State University and Youngstown State University Football Team projects. Transcripts housed at Maag Library and also online at www.maag.ysu.edu/oralhistory/oral_hist.html.

ACROSS AMERICA, PEOPLE ARE DISCOVERING SOMETHING WONDERFUL. *THEIR HERITAGE.*

Arcadia Publishing is the leading local history publisher in the United States. With more than 3,000 titles in print and hundreds of new titles released every year, Arcadia has extensive specialized experience chronicling the history of communities and celebrating America's hidden stories, bringing to life the people, places, and events from the past. To discover the history of other communities across the nation, please visit:

www.arcadiapublishing.com

Customized search tools allow you to find regional history books about the town where you grew up, the cities where your friends and family live, the town where your parents met, or even that retirement spot you've been dreaming about.

MAP SEARCH